Seeing with a
Painter's Eye

Seeing with a Painter's Eye

Second Edition

Rex Brandt

Notes on the Composition of Painting from the
Brandt Painting Workshops

VAN NOSTRAND REINHOLD COMPANY
New York Cincinnati Toronto London Melbourne

Copyright © 1984 by Rex Brandt
Library of Congress Catalog Card Number 82-83426
ISBN: 0-442-21422-7

Published by Van Nostrand Reinhold Company Inc.
135 West 50th Street
New York, New York 10020

Van Nostrand Reinhold Company Limited
Molly Millars Lane
Wokingham, Berkshire RG11 2PY, England

Van Nostrand Reinhold
480 La Trobe Street
Melbourne, Victoria 3000, Australia

Macmillan of Canada
Division of Gage Publishing Limited
164 Commander Boulevard
Agincourt, Ontario M1S 3C7, Canada

16 15 14 13 12 11 10 9 8 7 6 5 4 3 2

Library of Congress Cataloging in Publication Data

Brandt, Rex, 1914–
 Seeing with a painter's eye.
 "Notes on the composition of painting from the
Brandt Painting Workshops."
 Bibliography: p.
 Includes index.
 1. Drawing—Technique. 2. Painting—Technique.
I. Title.
NC730.B64 1984 750'.1'8 82-83426
ISBN 0-442-21422-7

CONTENTS

FOREWORD

What is called easel painting—in contrast to illustration, portraiture, or commercial art, for example—is as poetry compared to prose. Every stroke has meaning. The entire surface happens. The painting is finite, flat with an architectonic webbing into which colors are woven. To give meaning to this impersonal surface, the painter refers to the endless shape, value, and color relationships of the visible world, using them as metaphors.

To look only requires one to open his eyes. To see requires a special discipline. A botanist, a geologist, an ornithologist, and a painter do not see alike because they look for different things.

These notes and diagrams have been selected from my experiences as a painter and teacher to help you see— *as a painter*. There are no paintings here, just viewpoints. This is for you and your paintings, whether you make them, buy them, or just look at them.

Seeing relationships rather than things is the painter's role. Not easy, for the majority of us are object minded, prisoners of semantic orientations embedded deep in our heritage. The quest for relatedness requires appreciation, comprehension, and awareness more than creativity or invention.

To see with *loving* awareness, trusting the sensations of the eye, is to lose a deluded sense of self-importance and to experience something more rewarding than any prize or honor. It is why painting is important.

If all the world were clear
art would not exist.

—*Albert Camus*

He prayeth best, who loveth best
All things both great and small–

—*Samuel Taylor Coleridge*

INTRODUCTION

Why Paint?

A painting does two things: it mirrors the artist, and it mirrors his world. No wonder that history allocates a place for art, for it is a judgment both on the artist and on his times. What motivates the artist, however, is more complex and seldom completely apparent to either the painter or his audience. The following objectives will help to understand *why* paintings are created. Most often the reasons involve more than one rationale.

For Self-Realization

1. A way to see more, or at least differently.
2. Sensual satisfaction; the therapy of manipulating pigments and media.
3. Intellectual curiosity; exploring the psychology and physiology of color and value perceptions.
4. Ego; a star-struck fascination with the "Bohemian" ways of the artist.
5. Spiritual satisfaction; working with symbols and viewpoints inspired by religious faith.
6. In search of the sublime. The lonely pursuit of what is heroic in man and in art.

As a Means of Livelihood

A. Gallery Art: the painting as an object for sale.

1. Private art. Paintings for the home. Comparatively small and often sentimental. Chosen to please the home owner or his decorator.
2. Corporate or institutional art. Works are larger and more impersonal. A mural-like pretentiousness prevails. Critical standards change as fast as tax write-offs.

B. Assigned Art: the idea belongs to someone other than the artist.

Portrait paintings, murals, advertising art and various forms of illustration come under this generally lucrative classification. Most of the great murals and portraits of the past are examples.

Musicians like myself have to define terms or else we are at the mercy of the so-called experts.

—*Anthony Braxton speaking at CalArts*

C. Exhibition Painting: cash awards and scholarships as well as ego satisfaction.

Now that several millions paint in the United States alone, acceptance (by jury) in competitive exhibitions becomes as exciting if not as lucrative as a sports career. At best these events introduce new painters and ideas, rewarding the winners substantially; at worst, some exhibits are expensive lotteries with ribbons and little else for anyone.

It is important to understand that paintings that "make" competitive exhibitions are not the same ones that make sales records except for a handful of artists. Exhibitions thrive on novelty and the praise of the critics; professional art galleries, on the other hand, build the painter's image as the producer of a consistent identifiable work unique to the artist.

If all the above classifications seem disheartening, don't worry and don't fail your inner self, for nobody can beat you when you are yourself. If necessary, support yourself some other way. Keep looking with a loving, searching eye. You will win.

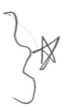

Kinds of Paintings

Like a good parent, the painter hopes for the best as his child, his work, goes out in the world. Days of agony and work mean nothing; what was intended is not always what is realized. The work stands alone to face the audience. This audience is astonishingly friendly and tolerant of even the slightest dab but is limited in willingness to look either deeply or at length. As far as I can see, it limits appreciation to one of the following three rationales:

1. *Imitation.* The work is validated by the recognition of things. However crude or faithful the representation, it is the ability to evoke associations within the audience that makes for success.
 Example: Wyeth, Rockwell.
2. *Communication.* The viewpoint of the painter — or his sponsor — is more important than what is depicted in referential terms.
 Example: expressionism.
3. *Formal or abstract quality.* The appeal is to the eyes much as music is to the ears.
 Example: Mondrian.

Although a painting may blend the above characteristics and, indeed, appeal variously to different members of the audience, the audience seems unable to recognize more than one quality at a time.

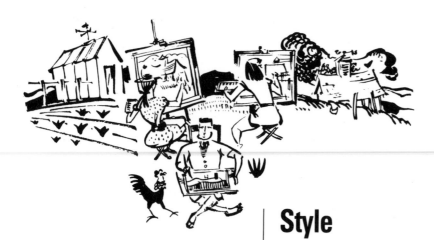

Style

Pictorial style is the imprint of the artist, or a group of artists (a school). It is the way he gets the act together; what is seen is tempered by the medium of paint, the ethos of the time, and his personal differences.

There is no such thing as *no style*. Like one's *life style*, pictorial style is the product of both conscious and subconscious influences, thus to some degree it can be imitated or disguised. At best it is the embodiment of the individual's strongest traits and firmest beliefs.

A painter's style may vary from decade to decade but seldom successfully from day to day. The following dichotomies display the contrasting considerations which shape the physiognomy of this work:

A. Outward versus Inward

Objectively, the work is developed like a theatrical production. It is for an audience. The intention is to entertain, communicate, and inspire. The subjective, inward, opposite, dedicates the work to self. Like a rosary or semantic graph, it helps solve personal problems, release creative urges, and provide therapy to the creator.

B. Referential versus Non-referential

The referential painter makes use of images and rhetoric commonly accepted as real or worldly. The non-referential shuns accepted signs and symbols, creating a personal imagery instead.

C. Form versus Content

Form: The painting is more important than any reference. Content: Communicative expressiveness is more important than the form in which it is expressed.

D. Illustrative versus Symbolic

Illustrative: Surface appearances are of primary importance. Symbolic: The essence of any experience is more important than how it looks.

Style:

The manner of expression characteristic of a work of art, a particular artist, a group (school) of artists, or even an epoch.

Every work of art that is an organic solution to a problem has a style of its own, while at the same time it may erect characteristics that belong to the style of the creator.

—*Encyclopedia of the Arts*

Suggested experiment:

Evaluate your artistic personality by determining a position on each of the four axes, allowing ten points for each. The result will describe a perfect circle midway to the extremes if you have a balanced style, but few good painters do. (Note the examples.)

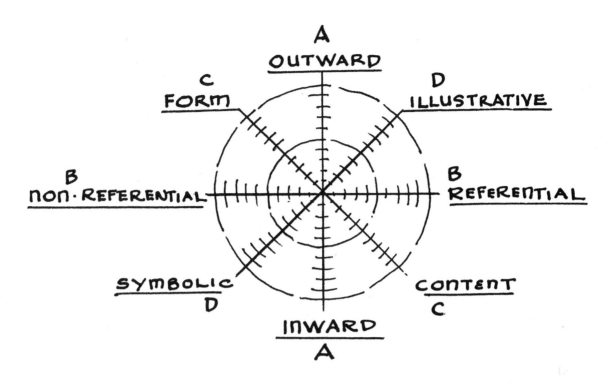

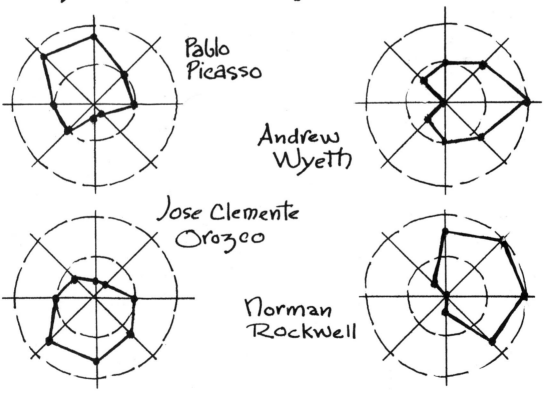

pictorial Style in profile

Pablo Picasso

Andrew Wyeth

Jose Clemente Orozco

Norman Rockwell

11

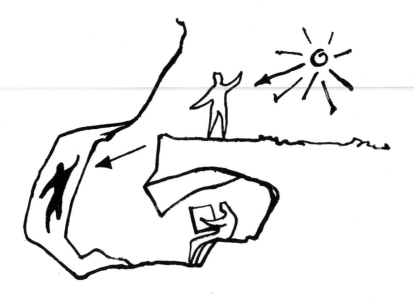

the parable
of the cave

What is Real?

With few if any exceptions, every painter who has ever lived considers his painting truthful. Like Plato's cave dweller, restricted to know the world beyond his confines only as shadows cast on a wall, the flat shadow patterns are real. He alludes to them in constructing a language with which to communicate with his fellow cave dwellers.

Actually he is involved with two concepts of truth, the reality of his canvas and paint *(form)* and the images and metaphors he experiences *(content)*.

The problem is to fuse the two realities as one art work. Not easy, for as he introduces images—whether perceived or imagined—to the flat surface of his medium, it suffers punctures and ruptures. The intimations of content compete with the reality of form.

Each needs the other. Metaphorical reality *(content)* is ephemeral, bodyless. The body *(form)* is lifeless. The history of painting is the story of the struggle to weld the two realities into one.

The painter learns to "listen" to the needs of his painting at the same time he learns to view his experiences as formal colors and shapes, savoring the reaction of one on the other. Ultimately content works through the matrix of form to pictorial truth, a work of art.

The Graphic Language of Art

Nothing on a canvas or sheet of paper is anything except by comparison.

A tree isn't large unless that next to it is smaller; figures don't lean unless they are compared to a firm vertical or horizontal; white is not white except as that next to it is darker. Hold this page against the light and observe how dark it is. An all-green painting is colorless. It is perceived only as value until you introduce another hue. (Add a stroke of red and see how green green can be.)

There are no *things* in a painting. No single nouns. Everything is comparative—pairs of nouns: dark/light, warm/cool, big/small, bright/dull, and so on.

The only *single* noun is the *painting*.

It is the whole show. The painter is the showman. His actors, pigments; his stage, the flat surface on which he paints.

More often than not the artist writes his own script. Sometimes, however, it is assigned by others, as in portrait painting, a mural, or commercial art. Whatever the source of the enkindling idea, the job is to *relate* the parts into an articulate, cohesive oneness . . . each segment dramatized by an active relationship to the next. A good painter can no more afford to waste space than can an actor afford to throw away lines.

Science strives to achieve unity of fact. Art strives to achieve unity of feeling.

—*Stephen Pepper*

Suggestions for seeing relationships:

1. Don't look directly at your subject. Open both eyes wide but try not to focus on anything. "Drink in" the relationship out of the corner of your eye.
2. If you have trouble evaluating a value or color, ask yourself two questions: (a) which is lighter? (b) which is warmer?
3. Hang loose when you look. Relax your stance, open your mouth, speculate.
4. Some painters appear to squint when studying the subject or the painting. Not so; if you look closely at them you will see that they are veiling the subject through their eyelashes to blur line and contour and better feel value-color relationships.

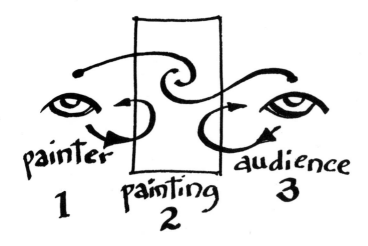

painter
1

painting
2

audience
3

A Painting Is a Challenge

Three entities create a work of art: the painter, the painting, and the audience. Each affects the other, causing the ultimate pictorial image to be seen quite differently from the artist's original perception.

The colloquy commences between painter and painting. The obdurate flat and finite surface channeling the painter's concept with its own formal disciplines. Ultimately idea and canvas are reconciled and the painting is on its own.

The painting, in turn, provides a stream of visual challenges to the audience. This "dialogue" is never the same, for each spectator "reads" shapes, values, and colors, as well as the images they may suggest, differently. (One of the fascinations in serving as an art juror is to observe the extraordinary variety of reactions jurors have.)

Because of these limitations, communication between painter and audience is never completely factual. The painting, like a poem, is a form of persuasion. What is left out can transcend fact in the imagination of the viewer.

The Many Ways of Art

One learns to paint two ways—empirically or eclectically—through practice or from others. In recent years the tendency has been to encourage the student to do his own thing, equating individuality with creativity and creativity with invention. No problem, except that it leaves many confused and discouraged.

Perhaps the reason eclecticism has failed in art teaching is that both teacher and student have been satisfied to imitate and copy rather than to appreciate and emulate the arts of other times and places. To emulate, one needs to understand the *who* and *why* of another—not just the *how*. In essence, to become for a while the person of the master.

It has been said that a writer cannot fairly criticize another's work unless he himself is capable of executing a reasonable parody of the subject. I think that this is true for the painter, too. I am constantly surprised at how few otherwise capable students, teachers, and professional painters can do this. Or even diagram another's composition. Little wonder they cannot analyze their own!

This may explain why few teachers like to demonstrate. It puts the emphasis on technical process rather than on the painting as an integrated whole.

The following assignment is a study in eclecticism. It is designed as an eye opener and mind bender. The students who have tried it have not lost their individuality but, rather, have quickly increased both perceptive power and creativity.

A great man does not confine himself to one school; but combines many schools, as well as reads and listens to the arguments of many predecessors, thereby slowly forming a style of his own.

—*Kuo Hsi, Chinese landscape painter,*
1278 A.D.

Technical notes:

The class visited the boatyard as a group. Prototypes were assigned on the basis of each individual's interest and on the availability of sufficient reference examples. No effort was made to duplicate medium or techniques, thus freeing the student to consider style and tradition. To minimize an overconcern with secondary effects, the works were kept to 4x6″ with a few exceptions, and the whole assignment set for completion within the one-day period.

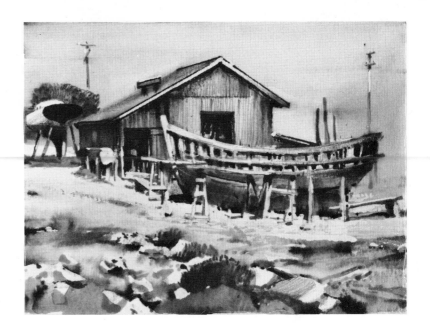

Photo Realism:
Adopting the camera's limitations reduces iconography to what is seen with one eye at one moment.

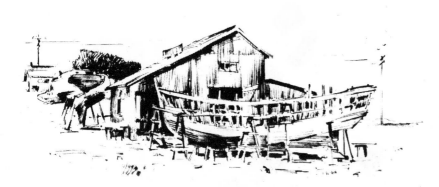

Pencil Drawing:
The artist's line synthesizes what two eyes see over a period of time. Texture functions as color.

Egyptian Frieze:
The form of a flat sandstone wall requires that images be presented as symbols which can be incised without the wall crumbling.

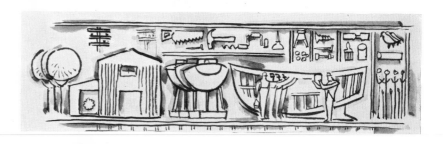

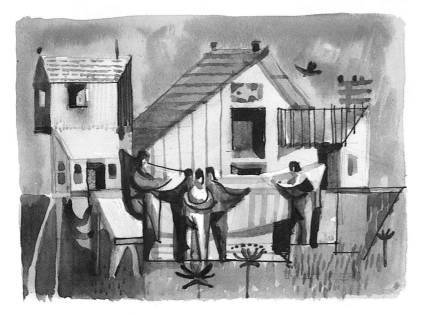

Byzantine:
The human figure dominates early Christian art. It is placed with dignity on a shallow stage.

Renaissance:
Staging became deeper and more dramatically lighted in the fourteenth to sixteenth centuries providing for greater variety.

Example: Raphael

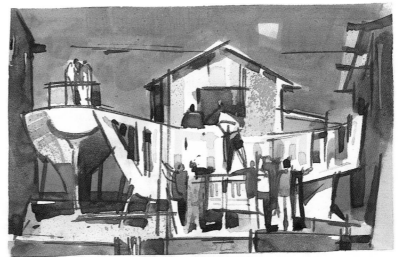

Painters of Chiaroscuro:
The stage dissolves into darkness. Figures advance into the light in informal, expressive attitudes.

Example: Rembrandt.

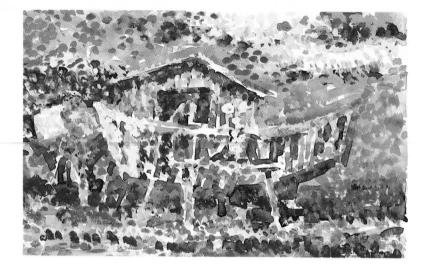

Impressionism:
Pigments mix optically when next to each other. The mosaiclike surface creates a sense of light.

Example: Monet.

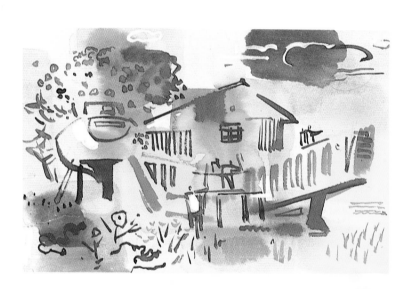

Open Color, Open Grid:
Color is freed from contour to perform like notes and chords in music. Images are implied with calligraphic strokes.

Example: Raoul Dufy.

The Fauves:
Color can be intoxicatingly expressive when freed from objective disciplines. Matisse and Derain fell in love with it.

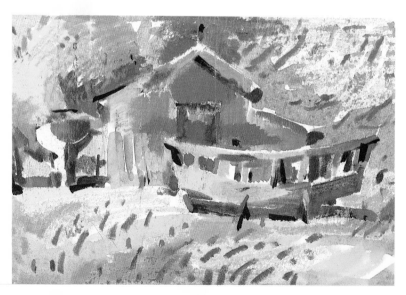

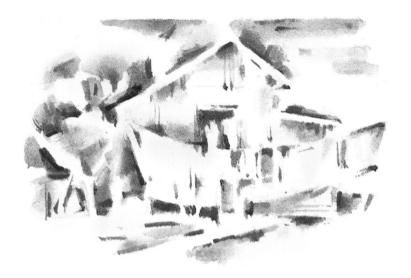

Post-Impressionism
By careful observation of the interaction of shapes, colors, and values, Cezanne developed a formal plastic order.

Cubism:
Picasso and Braque were quick to adopt Cezanne's language of planes to create solidity. In the process, color was lost.

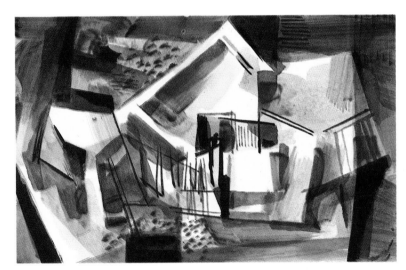

Expressionist Geometric:
Cezanne's articulated planes suggested a way to describe movement.

Examples: Duchamp's *Nude Descending the Staircase*, John Marin.

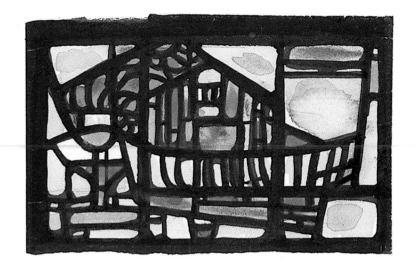

Stained Glass:
Thirteenth-century designers
found a way to exploit color yet
maintain form by enclosing glass
in dark patterns of leading.

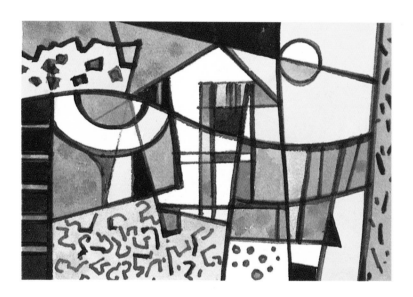

Architectural Geometric:
The Moderns syncopated color
and form by freeing color from
subject to operate in counterpoint
with line.

Example: Stuart Davis.

Northwest Indian:
Limited to the indigenous
pigments of the Northwest,
canoe-house artists used color
symbolically, confined by linear
pattern.

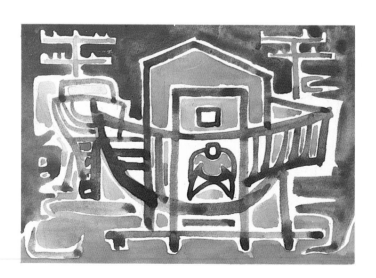

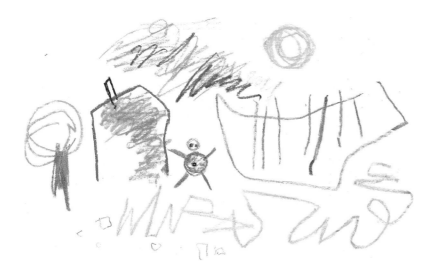

A Child's Drawing:
Everyone loves children's art but we don't want to look at it too long. There is no relationship between the parts.

Magic Realism:
A childlike simplicity can be magical when colors, shapes, and symbols are related with adult awareness.

Examples: Miro, Chagall.

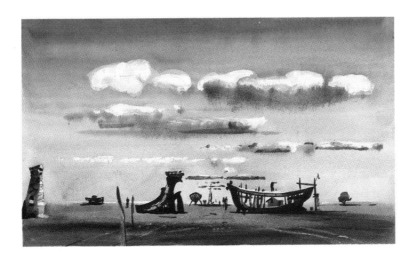

Surrealism:
Nineteenth-century psychology suggests that memories and dreams can be more real than direct experience.

Examples: Dali, de Chirico.

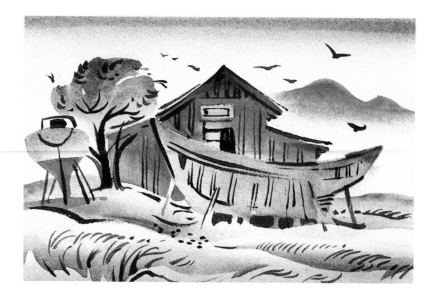

Oriental:
A Buddhistic faith that everything is Godlike justifies a feeling of life in every shape.

Example: Sung landscape.

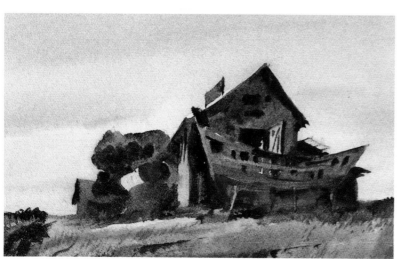

Luminism:
By painting silhouettes against the light, a simple romantic mood is created.

Example: Americans Moran, Heade, Inness.

California Watercolor of the Fifties:
Western subjects are geometrically simplified and juxtaposed on a golden, sun-filled background.

Examples: Dike, Barse Miller.

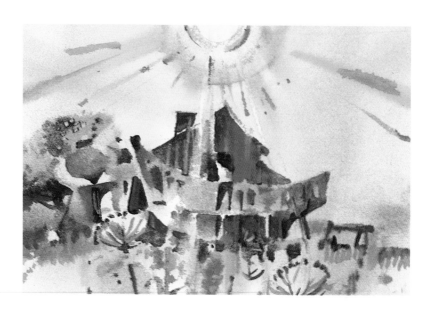

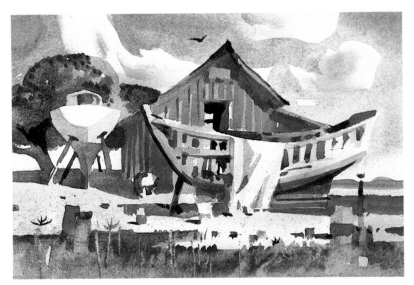

Naturalistic Geometric:
Classic stylization related to light and air creates a poetic and decorative art form.

Examples: Rockwell Kent, Sheets, Post.

Biomorphic:
Nature is seen as a gravity-free slice of tissue in which images float as if in protoplasm.

Examples: Miro, Gorky, Tchelitchew, Watercolorists Jenkins, Crown.

Pop Art:
Like graffiti on a subway wall, colors and images are borrowed from the twentieth-century urban milieu.

Example: Rauschenberg.

23

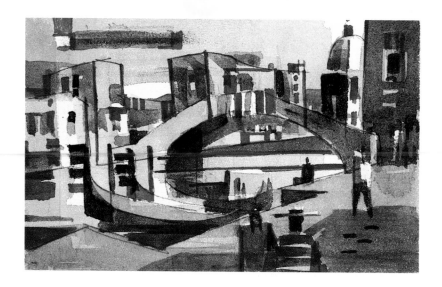

Intellectual

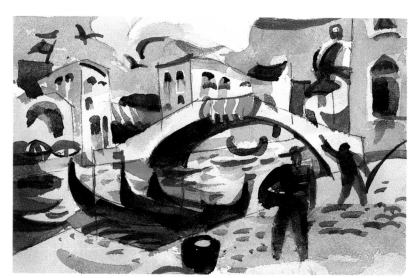

Sensual

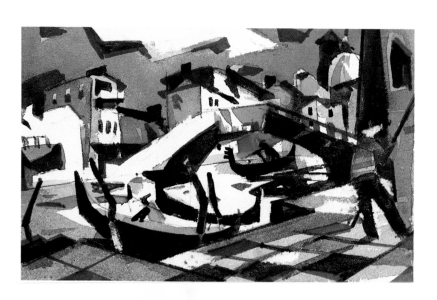

Emotional

24

Intellectual:
The mind dominates, seeking order. Architectural vertical/horizontal alignments provide boxes in which objects are arranged hierarchically Colors are used as identification or applied with harmonic logic.

Examples: Egyptian, Greek, early Italian arts.

Sensual:
Curves interlace like the organs in the body. Textures are tactile—velvet, fur, and flesh. Colors are reminiscent of food and flowers, appealing to the nose as much as to the eye.

Examples: Raphael, Rubens.

Emotional:
One expects a diagonal to either fall down or erect itself. The suspense is terrific. Colors are employed for their shock value rather than to soothe or beguile.

Examples: El Greco, German expressionists, John Marin.

Photograph of subject at Venice.

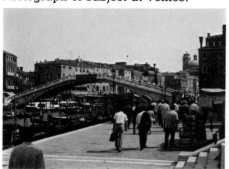

Personality Differences

"Learn this but be yourself," says the teacher.
"Be different," the critic demands.
"I need three more small, warm-toned paintings," the dealer implores.

Individual style is buffeted by social pressures as much as it is influenced by group or personal esthetics. Little wonder the fashions in painting are so transient. But the individual's personality, as unchanging as handwriting or a fingerprint, can validate his art and establish its uniqueness if he will recognize it.

Too often we fail to recognize, and therefore exploit, our own personality. We may fight to be logical when perhaps we should trust intuition; or, we may strive to be dramatic (because a dealer suggested it?) when our forte is formal purity. In essence, we try to remake our image by changing our handwriting—frustrating, if not impossible.

Like a professional prize fighter, learn what your strengths are. Be aware of your weaknesses and do what is possible to overcome them. But, when in the ring, *hide them*. Nobody can beat you at *your* game!

Psychologists affirm that we have at least three sides to our personality: mind, emotions and sensuality. Each affects your style. Individuals differ as to which dominates. Identify it and exploit it as your own.

Definitions:

Form does not mean volume, esthetically. It means unity, the painting, the *one thing*.

Content is more than "subject matter." It is all the feelings and ideas you bring to the painting.

We give *form* to our ideas.

Our *ideas* form our art.

Content and container are inseparable; one exists by virtue of the other.

—Rene Huyghe

I was converting an old chair and some scraps of wood, cloth, wire, and glue into *Madonna of the Chair.* Part way along I picked up the forming assemblage in a way that caused me to blush. My fabrication was there. *She* accosted me with her identity. From then on I was careful to respect HER.

Form is not a reflection of the world . . . it *is* the world.

—Kant

Form: Content: Form

Which comes first: content or form? seeing or painting? perception or conception?

Although form and content are inseparable, it is important for the artist to recognize how each influences his concept. For example, the sculptor finds a twisted root *(form)* and sees in it the figure of a mermaid *(content)*; or, he sees the mermaid and then selects a material *(form)* to accommodate his vision. Either way, he will work towards a reconciliation of the one with the other so that the result is neither a twisted root nor a mermaid but a *work of art*, Form and Content.

Some students are motivated by what they want to say. Others are fascinated by the mediums of art—dripping paint, gooey clay, textural collages, and so on. Regardless, you will find yourself alternating as you proceed—idea–medium–idea–medium—until your goal is reached.

Steps from Idea to Art

Whether inspired initially by content or by form, the development of the painting progresses by the give and take of each. For example a lofty mountain *(content)* invites the choice of a vertical format. This form, in turn, predicates what minor shapes are to be selected. The linear pattern thus developed influences value, color, and textural selections. The painting grows organically. The artist is the mediator, adjusting the development both conceptually and perceptually.

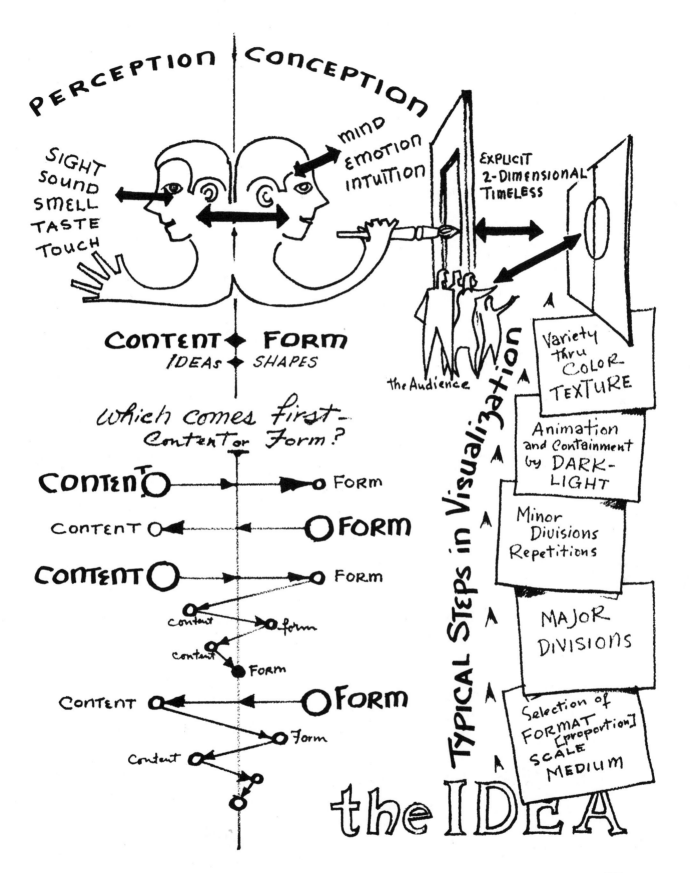

PERCEPTION | CONCEPTION

SIGHT
SOUND
SMELL
TASTE
TOUCH

mind
EMOTION
INTUITION

EXPLICIT
2-DIMENSIONAL
TIMELESS

the Audience

CONTENT ◆ FORM
IDEAS ◆ SHAPES

Which comes first—
Content or Form?

CONTENT ○ ▶ ▶ ○ Form

CONTENT ○ ◀ ◀ ○ FORM

CONTENT ○ ▶ ▶ ○ Form
Content ○ ○ form
Content ○ ● Form

CONTENT ○ ◀ ◀ ○ FORM
○ Form
Content ○ ○
○

Typical Steps in Visualization

Variety
thru
COLOR
TEXTURE

Animation
and Containment
by DARK-
LIGHT

Minor
Divisions
Repetitions

MAJOR
DIVISIONS

Selection of
FORMAT [proportion]
SCALE
MEDIUM

the IDEA

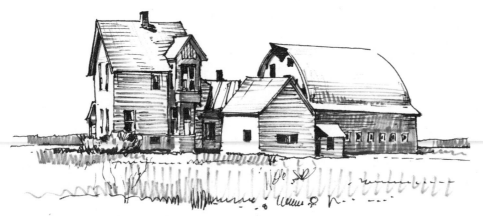

Ink + felt pen sketch

FARM in SKAGIT VALLEY

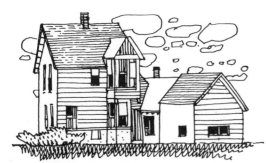

FORM
..as medium..
..as technique..
influences the Concept

a Rapidograph pen finds formal textures

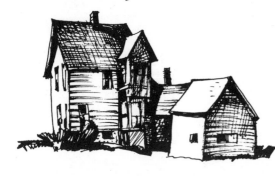

Line + cross-hatch develops
Weight and volume

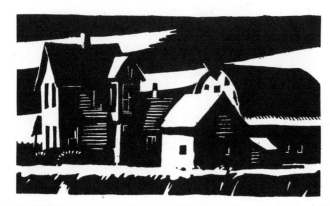

Linoleum Block cuts
require bold, alternations
of dark vs. light
[counterchange]

a stained glass design
requires geometric bars +
flat color shapes

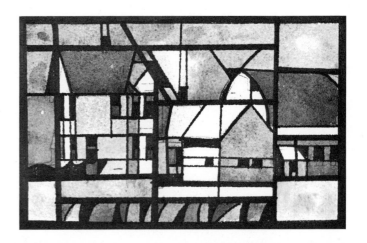

two
different
painting
techniques

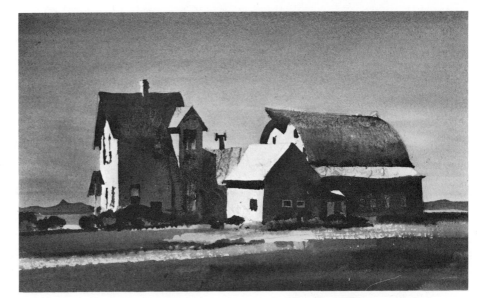

Gradated wash
emphasizes shape
and silhouette

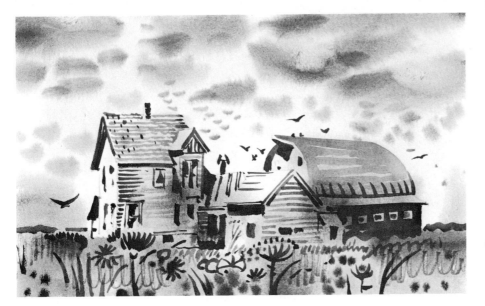

Calligraphy and
drybrush invites
secondary patterns
and texture

Form versus Content

Whether you view these examples as two-dimensional drawings or as three-dimensional carvings, the lesson is the same: Content is advanced at the expense of form, and vice-versa. It is up to the artist to determine the balance point.

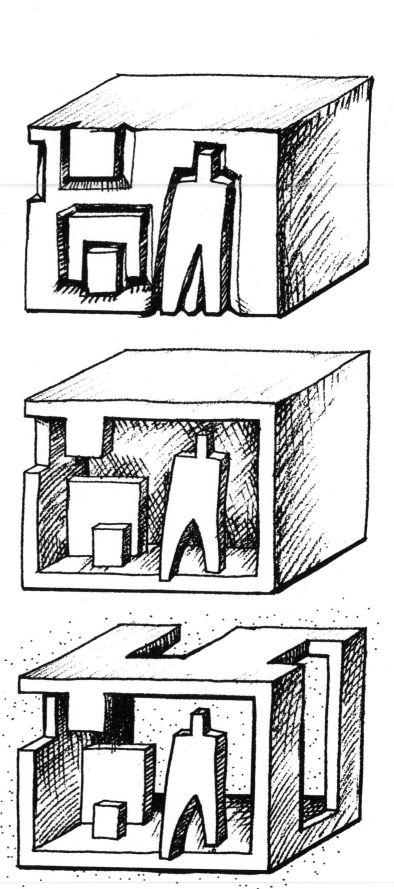

Shallow Space:
Formal unity is preserved by restraining imagery to a shallow treatment of the surface. Cezanne painted watercolors this way, preserving white paper grounds throughout.

Deeper Space:
The boxlike unity of the design is preserved but with an increase in positive/negative quality as the images are developed in depth.

Open Space:
The unit breaks into free-standing new forms. Their separateness ruptures the first form.

PART II:
LINE DRAWING

Drawing: The basis of every pictorial experience, particularly that of painting.

—*Encyclopedia of World Art*

To the draftsman, line drawing is an end in itself, a way to isolate and define things. Until he has drawn it, he feels he doesn't know it. When the drawing is completed it can stand alone. The painter, on the other hand, employs line speculatively, as a way to explore, think about, and set up shape relationships which will be ultimately developed in paint.

William Blake was a good draftsman whose paintings looked like colored drawings; conversely, Rembrandt drew in a loose, exploratory manner which invited finalization as paint. The abstract expressionists shunned drawing as an impediment to painting in contrast to Andrew Wyeth, who draws with a brush.

Most of us are better draftsmen than painters because we have learned to think in linear terms rather than in the language of tone and color. We are comforted to be told that a "good drawing makes a good painting." Unfortunately, this is not so. To open the door to a good painting, a drawing must be more provocative than final.

Line can assist the painter, among other ways: 1. as an investigation and exploration of subject matter 2. as a compositional preliminary.

What Line Does:
An Introduction

Distance is compared.

Direction is measured as an angle between two lines.

Movement along a line appears to extend beyond its ends.

Movement along a curved line extends the radius of the curve.

Optical lines are created when a series of points or shapes are aligned.

Optical pull is experienced when alignments are interrupted.

Explicit shapes are created when lines meet or cross each other.

Implicit shapes are created when lines meet optically.

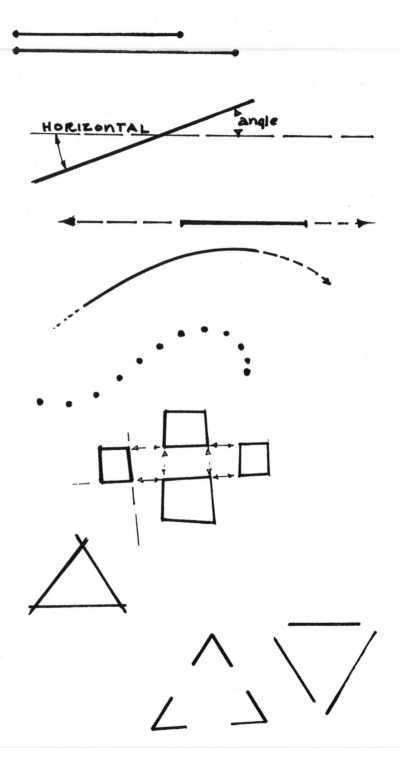

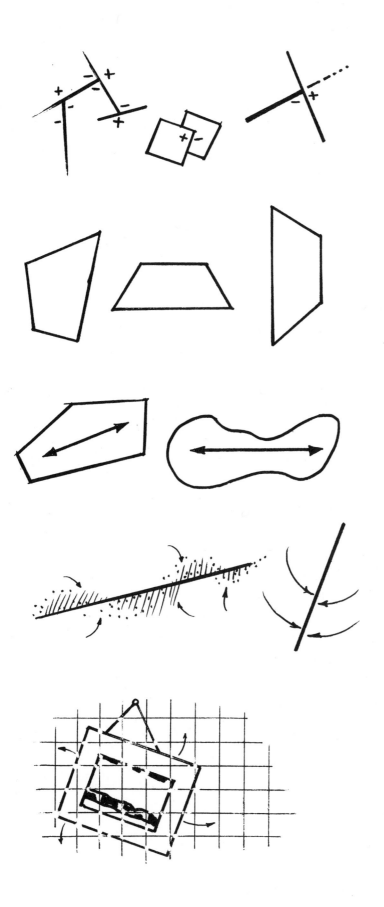

Intersection of a line with another causes the interrupted line to appear to continue underneath. The potential shapes created at the point of intersection assume an up (+) – down (−) relationship to each other.

Diagonal components of a shape cause it to appear to thrust from the picture plane. (Rectangles do not thrust in this way.)

Axis is an optical line summarizing the principal direction of a shape.

Interfacing line is that section of a shape's boundary which is most actively related to an adjoining shape. It is analogous to the football player's "scrimmage line," where interaction occurs.

The ever-present **grid** (or **grille**) is a gravity-inspired interlace of horizontal-vertical lines, felt but not seen. Most people are "picture straighteners" because of a compulsion to align shapes with the grid.

Three Kinds of Drawings

(Refer to the photograph of the subject on page 66.)

A. A Tracing from the Photograph

Keith Crown says, "A photograph doesn't lie—it just doesn't tell the truth." Outlines separate shape from shape. Linear perspective, the product of the camera's single-eye, causes the large trees in the distance to shrink, the close ones to expand. The result: nonselective images with little decorative continuity.

B. Investigative Drawing

From early childhood, man has needed to identify things. His line drawings become a tool for separation rather than integration. This is epitomized by the art of children and primitives: because their shapes are unengaged, the opportunity to orchestrate value and color is limited.

C. Inductive Drawing

By requiring each line to meet the next, shapes are compared each to the other, providing the painter with a way to orchestrate value and color. Space is created by the illusion of overlap instead of by the rules of perspective. All the parts relate to each other organically.

You can only learn to paint by drawing, for drawing is a way of reserving a place for color in advance.

—André L'Hote

By drawing, man has extended his ability to see and comprehend what he sees.

—Frederick Gore

Drawing is a selective process. One can't get it all down. The artist literally *draws his own conclusions.*

34

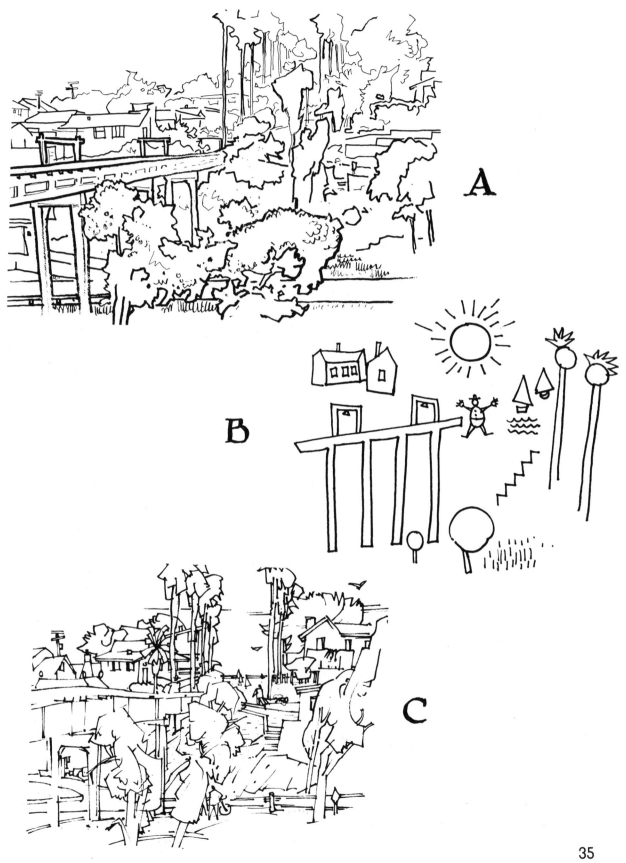

A

B

C

Feeling *to* Line *to* Shape

Most shapes in Nature are a mixture of curved and straight lines—so greatly mixed as to obscure their essential character and to complicate delineation. But, by singling out one or two important directions and then seeking their repeats in the subject, the painter can capture the essence and at the same time give rhythm to his design. For example, two different diagonals can give birth to a series of triangles which are all cousins, one to the other. These repeated shapes have both genetic similarity and rhythm.

By allowing his feelings to guide him in the selection of a dominant linear quality, the painter can establish a basis for both form and content.

> I will speak of the beauty of shapes, and I don't mean just shapes of living figures or their imitations in painting, but *straight lines* and *curves* and the *shapes made from them.*
>
> —*Plato quoting Socrates*

Qualities of Lines

Verticals: austere, dignified, spiritual.

Horizontals: calm, restful, enduring, expansive.

Diagonals: tense, restless, alert, explosive.

Curves: The common denominator is the radius or amplitude of the curve. For example, curves of short radii—such as those drawn with the fingers or turn of the wrist—feel germinative, visceral, and nervous while flatter curves appear lyrical, graceful, and earthy.

The examples on the opposite page are abstracted from this predominantly curvilinear drawing.

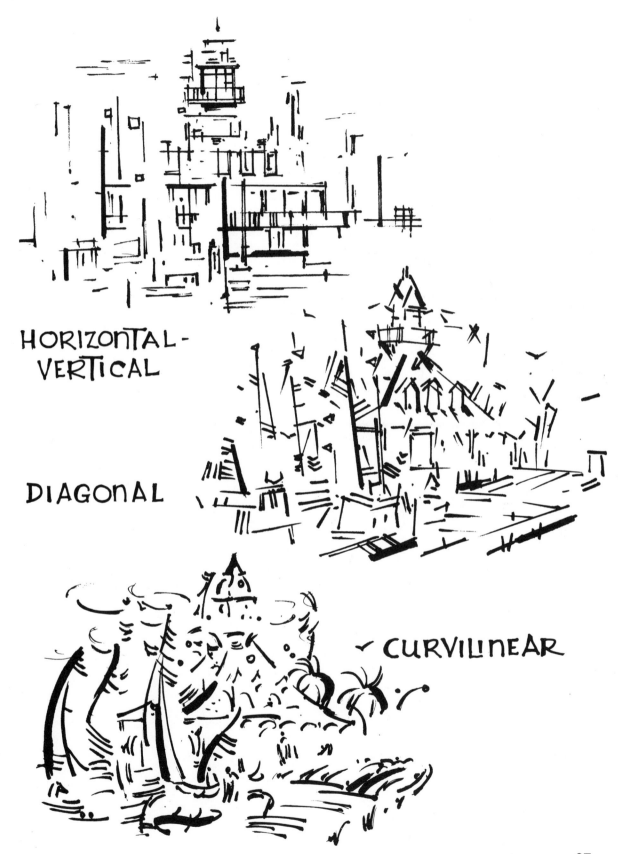

HORIZONTAL-
VERTICAL

DIAGONAL

CURVILINEAR

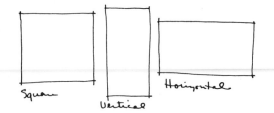

Square Vertical Horizontal

A painting is good not because it looks like something but rather because it feels like something.

—*Phil Dike*

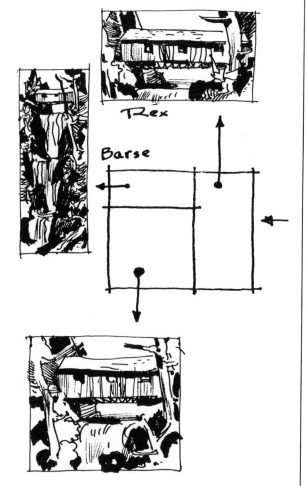

T-Rex

Barse

Size and Proportion of the Format

It seems so obvious as to barely justify mention, this matter of selecting an expressive and decorative picture format or shape, but I rank it with bad color as the most common oversight in painting. More painters have labored more long hours trying to fit square ideas into long shapes, and vice-versa, than can possibly be imagined.

Most proportions for canvas, frame, and paper are based on the Golden Mean. (The diagonal of a square is used to make the longer proportion.) Such a proportion, together with a standard size, has much in its favor (such as affording uniform sizes of frames, mats, storage, and so on), but has not necessarily the most expressive potential.

The *rectangle* with *horizontal* dominant is most accommodating to landscape ideas. (About the same shape vertical is most often used for the human figure.) When the horizontal is grossly attenuate (say three times as long as it is high, as in the Chinese scroll paintings), special composition problems arise; but so do the rewards in expressive power.

The *vertical* shape is stately and dignified, and the modern home with its freer treatment of interior space permits this shape as wall decoration. Like the horizontal, the attenuate version is more difficult.

Most organic is the *square* shape. The arabesque is the key to its effective use.

Learn from the masters: Barse Miller used to prepare for a sketch trip by dividing his watercolor sheet into three very different proportions. Once a subject was selected, he chose the board that best accommodated his feelings. Painting one day at Jericho, Vermont, I did my usual half-sheet. Barse chose a more extreme rectangle. When he emerged in a few hours with a cascade of vertical shapes, he taught me a lesson: Avoid the ordinary, seek the expressive from first shape on.

FORMAT

VERTICAL

Dignity . Austerity

SQUARE

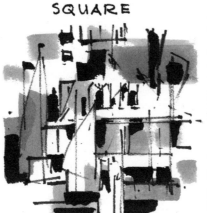

Massive/structural

VERTICAL · HORIZONTAL

HORIZONTAL

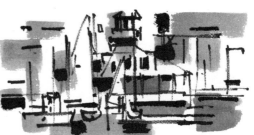

Rest - Calm - Finality - Space

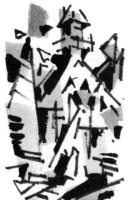

Soaring/thrusting

Violent action/Contrast

DIAGONALS

Continuing movement

Ascending-growing

Visceral - sensuous - earthy

CURVES

Lyrical

39

The Poetics of Line/Shape

The apprentice realist uses line as a net to capture his prey, an imitation of reality. But soon he becomes enchanted with line as a thing. It becomes a servant of his pleasure.

—Rene Huyghe

Can you feel your body soar when you enter a cathedral or a forest? hunch when moved by sympathy? lean with wind-blown sailboats? The artist reveals such feelings with each stroke of his brush.

Empathy vs. *Sympathy:* Empathy is feeling into or of; sympathy is feeling for. Let *empathy* help you to find the right line, each muscle and bone responding to the image in your eye.

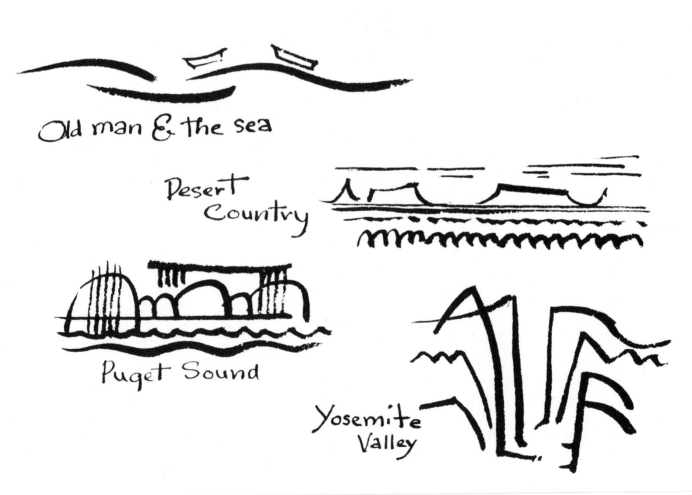

Old man & the sea

Desert Country

Puget Sound

Yosemite Valley

Typical Linear Motifs

FALLING LEAF
Sumptuous/graceful

SLEET STORM
Rhythmic/monotonous

ZIG-ZAG
Restless/energetic

GRIEF LINE
resigned

ROMAN ARCH
massive/stolid

GOTHIC ARCH
like a forest interior

SPIRAL

FLAME

PYRAMID

Articulate Drawing

Lines bound shapes, the dishes on which the painter serves his values and colors. They influence the painting in much the same way that a foundation defines the character of a house. They need to be clear and well articulated, defined by straight lines and firm curves. The law of parsimony prevails—the simplest answer that fits is the strongest answer.

Ways to a More Graphic Drawing

1. To put bones in the drawing, draw with wrist and arm in radius arcs and straight lines. To reduce the chance of niggling, hold the brush or pencil like a palette knife or trowel, the handle in the palm rather than above it.
2. Block out shapes as big, cubical volumes with a minimum of curves. To refine the character of a silhouette, trace it with gestures of the arm first, repeating the gesture in the air as many times as necessary to get it right before putting it on the sheet.
3. Experiment with arrangements of simple geometric shapes—triangles, squares, rectangles, and circles—to define the shape in the simplest pattern possible without losing its character. (The Japanese teach drawing this way, requiring the beginner to simplify every shape geometrically.)
4. If for some physicial reason you find it impossible to lay in clean strokes and regular arcs, use a ruler or other drafting aid. One way or another, the drawing must provide a firm scaffold for the painting.

. . . geometry is to the plastic arts what grammar is to the art of the writer.

—*Guillaume Apollinaire*

Character is in the external form— round, oblong, square or otherwise—.

—*André L'Hote*

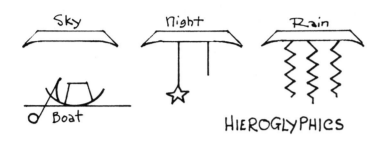

Sky night Rain

Boat

HIEROGLYPHICS

GP PARIS 62

sketch by George Post

THE LAW OF PARSIMONY SAYS:
the simplest answer that fits
the facts is the strongest.

To reduce complexes of line to
||||| VERTICALS ≡ HORIZONTALS ⟋⟍ DIAGONALS ⟳ RADIUS CURVES
is a way to the ESSENCE of Line, and thus of SHAPE

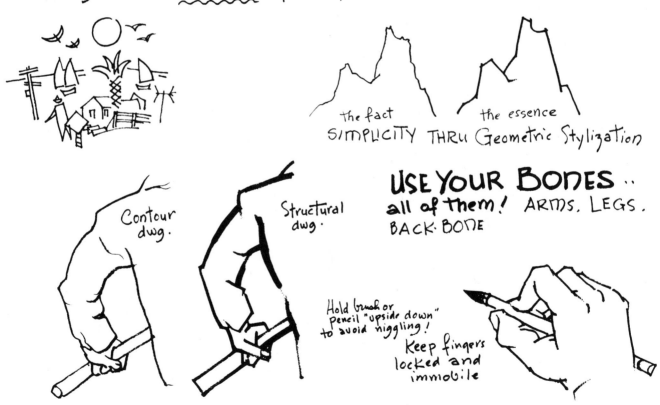

the fact the essence
SIMPLICITY THRU Geometric Stylization

Contour dwg. Structural dwg.

USE YOUR BONES..
all of them! ARMS. LEGS.
BACK·BONE

Hold brush or
pencil "upside down"
to avoid niggling!
Keep fingers
locked and
immobile

Tension: The Magnetic Effect

Tension is that quality of strain or pull felt when something is out of line, a rhythm is interrupted. Like muscular tone in the human body, it is expressive of vitality and life.

Linear tension requires firm, architectural components, offset to provide the magic spark. Random strokes and aimless curves are as incapable of conveying this life force as is a boneless figure.

When I tense up a drawing, my legs brace each other, jaw muscles set. Then I feel an exhilarating flow of nervous energy.

As you arrange shape against shape, think of two magnets—too far apart, no attraction; too close together, they clutch each other as one; but just far enough apart, they pull dynamically.

Tension is anticipation and uncertainty. Every art has to have it.

Violating, rather than resolving, a pattern of expectancy can heighten dramatic effect.

Static

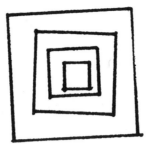

Tense/Dramatic

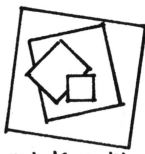

Melodramatic

static
appeals to the sense of order

almost
over/tensed
appeals to feelings
and muscles

FACTUAL

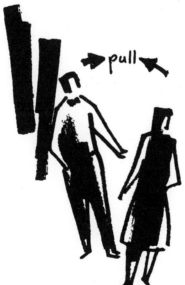

pull

DRAMATIC

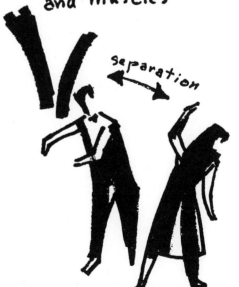

separation

Melo. DRAMATIC

45

Signs, Symbols, Silhouettes

Because most of us in this scientific and material world are "thing-minded," seeing several objects as one is a discipline to be acquired with practice. Drawing means literally "drawing out," searching for the essence of a shape or configuration of shapes.

A handful of rectangles, triangles and circles can "spell out" almost anything, depending on the relation of each to the next. Here are some of the relationships:

1. *Axial Orientation*. A vertical pattern of waves says "waterfall," the same pattern presented horizontally describes land and sea. The figure "Y" looks something like a bare tree; upside down it resembles a headless figure, and so on.

2. *Association*. The horizontal "wave" pattern reads as rolling hills when house shapes are interspersed; but it is water when sail symbols are substituted.

3. *Silhouette*. In perceiving silhouette, as in speed reading, we grasp complex patterns as one, a configuration, filling in details by association with prior experiences. The artist uses this "legibility of the unsaid" to increase the range of his expression while preserving decorative simplicity and flatness. Its effect on the audience is as successful as that of the experienced stage performer who has learned not to explain the punch line.

The principle of parsimony is valid esthetically in that the artist must not go beyond what is needed for his purpose.

—*Rudolf Arnheim*

I wished to copy nature. I could not. But I was satisfied when I discovered that the sun, for instance, could not be reproduced, but only represented by something else.

—*Cezanne*

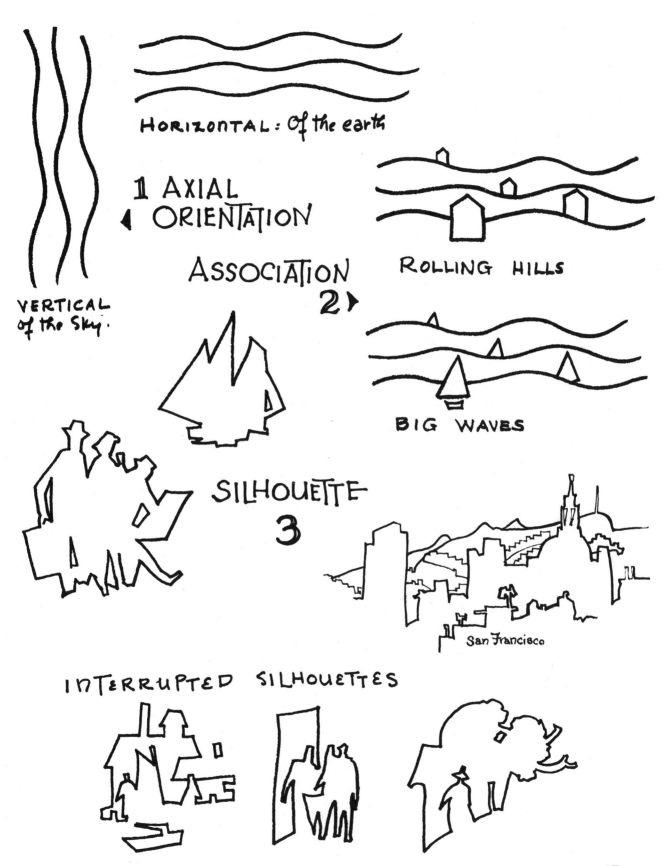

HORIZONTAL: Of the earth

1 AXIAL ORIENTATION

VERTICAL of the Sky.

ASSOCIATION 2▸

ROLLING HILLS

BIG WAVES

SILHOUETTE 3

San Francisco

INTERRUPTED SILHOUETTES

Shape versus Shape

When shapes are placed in proximity to each other, changes of size (scale) and varied degrees of engagement/disengagement occur; and the third dimension with its problems and potentials arises as a product of the illusion of intersection and overlap.

Scale

A. A large foreground shape against a comparatively small background has a bold, aggressive, decorative feeling.

B. A small positive shape against a comparatively large negative shape has a lonely but precious feeling.

Examples:

I asked Paul Lewis Clemens why he painted Madame Ouspensky so small on such a large canvas. He answered, "She is the tiniest actress I have ever painted. I *had* to place her on an oversize canvas."

Charles Burchfield, in commenting on the large format of the watercolor *The Elm Tree*, is reported to have said, "It was the biggest tree I have ever seen, so I had to choose a big sheet and even then, paint it off the edges of the sheet. . . . "

Engagement

1. Two shapes of equal size cohere if they share a common side. They are conjunctive.
2. Two shapes of unequal size relate more dramatically than the above, *provided, however,* they are not too extremely different in size. For example, if the narrower shape were as thin as a shoestring it would appear unrelated.
3. Equal adjacent areas are related more aggressively by a "tongue and groove" interlock.
4. Unequal areas, as above, seem more exciting than equal areas.
5. Areas that are equal but reversed in their attitudes by a common diagonal appear more aggressively related than if the common divider is static (vertical or horizontal).
6. When the interlocking shape is surrounded so as to be inseparable—like a piece in a jigsaw puzzle—the feeling of engagement is absolute.

Interlock

Mechanics lock a wheel to an axle by the introduction of a third element, a square key inserted into grooves (keyways) in the first two shapes. The artist may use a small shape, common to two others in the same way, to relate conjunctive figures positively. George Post describes these small integrators as "Johnny Jump-Offs" because they provide a visual gateway between figures.

48

SCALE

Decorative / Bold Informational / average Reclusive / exquisite

ENGAGEMENT

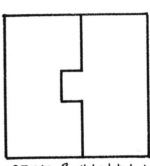

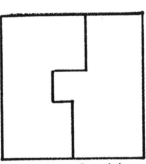

EQUAL - Parallel - Adjacent UNEQUAL ⟨ Parallel Adjacent EQUAL - Parallel + Interlock UNEQUAL ⟨ Parallel + Interlock

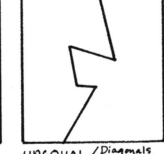

INTERLOCK FUNCTIONS IN THE SAME MANNER THAT A MECHANIC'S "KEY" IS USED TO SECURE A WHEEL TO AN AXLE

EQUAL ⟨ Diagonal + Interlock UNEQUAL ⟨ Diagonals + Interlock

Shapes secured by interlocking "THIRD" shape

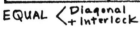

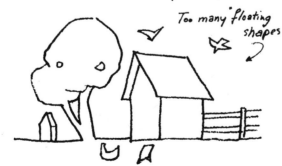

Too many "floating shapes

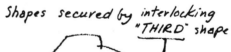

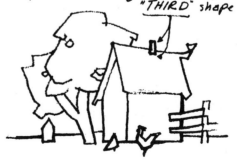

Space

Experience is required to translate an architect's drawings, a road map, or even a photograph or perspective drawing into measures of depth and scale. (It is reported that untutored aborigines do not comprehend a photograph on first inspection.) But some linear relationships are immediately readable. Here are three:

1. **Scale.** A larger shape appears nearer than a smaller, similar shape, and vice-versa.
2. **Position.** A perpendicular picture surface seems to fall away from the observer, the lower edge appearing nearer than the upper. For this reason the uppermost of two equal-sized shapes seems larger.
3. **Overlap.** When the boundary of one shape is intersected by another, the interrupted shape will appear to continue *under* the first figure irresistibly. Even nonadjacent shapes will appear spatially related by a third shape or by a single line, when this modulator appears interrupted.

Conversely, the spatial illusion is minimized or negated by the following devices:

1. **Tangency.** Shapes abut but do not intersect.
2. **Transparency or equivocal shapes.** By extending shapes "through" each other, space is collapsed.
3. **Separateness, flotation, or silhouette.** As long as shape does not actually engage shape, however minutely, positive plastic commitment is avoided.

No power on earth can keep the picture from being three-dimensional once the first line is drawn or color-plane applied.

—Sheldon Cheney

It is hard for a flat thing to understand a round one.

—Arthur Dove

Opposite Page:
The signs + and − designate the relative position of one shape to the next, the minus indicating the more recessive.

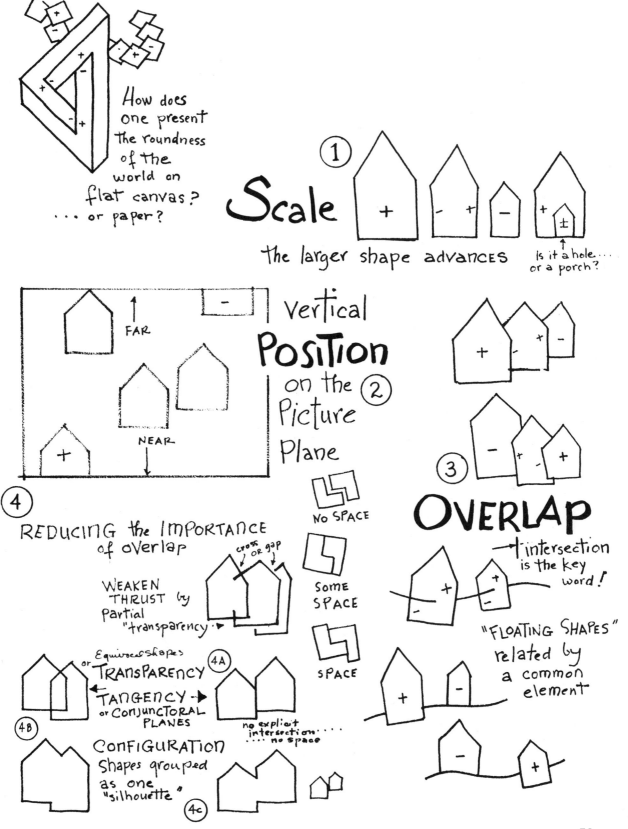

How does one present the roundness of the world on flat canvas? ... or paper?

① **Scale**

the larger shape advances

Is it a hole.... or a porch?

Vertical **POSITION** on the ② **Picture** **Plane**

FAR

NEAR

④

REDUCING the IMPORTANCE of overlap

cross or gap

WEAKEN THRUST by partial "transparency"

Equivocal shapes or **TRANSPARENCY** ④A

TANGENCY or CONJUNCTORAL PLANES

④B

no explicit intersection.... no space

CONFIGURATION Shapes grouped as one "silhouette"

④c

NO SPACE

SOME SPACE

SPACE

③

OVERLAP

intersection is the key word!

"FLOATING SHAPES" related by a common element

51

"Like a theatre"

Standpoint

No matter what system of projection or construction is used to relate figurative shapes, the question of orientation arises: "From where am I looking?" The answer has a great deal to do with both the mood of the painting and the style of the artist. Unfortunately, too few artists select the most descriptive or poetic standpoint, perhaps because it is a physically impossible standpoint. Fortunately for the painter with a modicum of training, the viewpoint may be altered in his mind even as he stands in eyeball-to-eyeball confrontation with the subject.

The ancient Chinese landscape painters described three viewpoints as appropriate to lyrical art: looking up, looking down, and looking across. They contended, "the more extreme, the better." Cezanne affirmed the concept with his telephoto views of Mount St. Victoire. By bringing the distant mountain forward, as if viewed in a telescope, he minimized distortion and at the same time dramatized the size of the mountain.

Standpoint:
In perspective projection, the position of the eye in relation to what is perceived.

1. *Eye level.* The Brownie Camera, eyeball to eyeball, pedestrian view.
2. *Distance.* There is less distortion of proportion when the distance between eye and subject is greater.
3. *Below eye level.* The bird's-eye or map-maker's view provides a better orientation of space. It is the favorite of landscape painters, Oriental artists, children, and primitives.
4. *Below eye level + distance.* Less distortion occurs, shapes are more conformal. Because Cezanne wanted to avoid distortion he favored this viewpoint.
5. *Above eye level.* It comes as a surprise to many, but any shopkeeper will tell you that no one looks at anything on a shelf higher than the level of his eyes. This may explain why the upward view seems uninformative to some eyes.

Scale

The distance between the observer and a shape may be influenced by the proportion of background (the so-called "negative space") to the shape. Note how the three identical viewpoints at the upper right, facing page, seem to present the houses at different distances: Example 2B seems much more distant than 2A.

High / Low
Near / Far

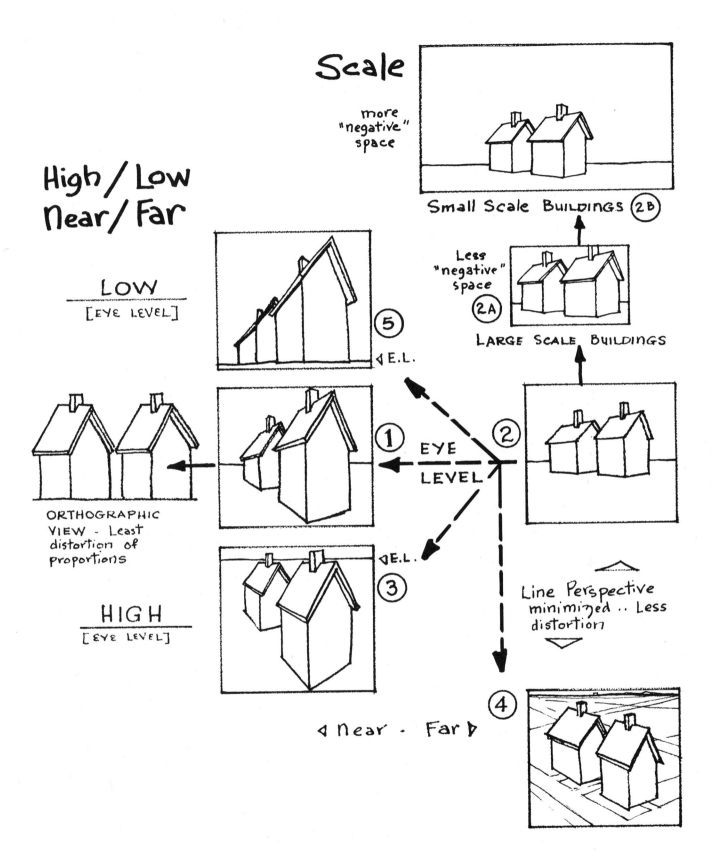

Scale

more "negative" space

Small Scale Buildings ②B

Less "negative" space ②A

Large Scale Buildings

LOW
[EYE LEVEL]

⑤ ◁E.L.

① EYE LEVEL ②

◁E.L. ③

Line Perspective minimized .. Less distortion

ORTHOGRAPHIC VIEW - Least distortion of proportions

HIGH
[EYE LEVEL]

◁ Near - Far ▷

④

53

The Problem of Perspective

1. *Line perspective.* Actually centered on the table top, the bottle appears to retreat due to foreshortening. But worse, the eye is led out of the frame by the expanding triangles produced from the radii of the vanishing point. Note how excessively important the near edge of the table becomes.

2. *Perspective, high eye level.* Instinctively, most painters compensate for perspective distortion by raising the eye level to balance the space in front to that behind the bottle.

3. *Perspective, very high eye level.* Cezanne and the Oriental landscape painters reduced the pinching effect of the vanishing points by a maplike "telephoto" view of the subject. Such a view permits the bottle to appear forward of true center, thus helping balance the space in front with the space behind.

4. and 5. *High versus low viewpoints.* Probably because the earth provides more reference points than the sky, a high viewpoint seems more satisfying than a very low viewpoint.

6. *Multiple viewpoints.* By combining several viewpoints, the best of each figure can be revealed. For example, a "straight-on" elevation of the bottle is related to a maplike, "bird's-eye' view of the table.

7. *Orthographic elevation.* The simplest way to avoid the traps of the vanishing point is to choose two-dimensional subjects. An architect's "side-view" is typical; or select two-dimensional subjects. For example, instead of the barn, choose a barn door, a hinge, lettering on a wall, or another flat subject.

8. *Inductive or relational drawing.* The best and most natural way of all is to replace the static, one-eyed concepts of perspective with a roving pair of eyes, comparing the angle of each line and shape to the next. The result is a dynamic integration of viewpoints, more exciting than any projection formula.

9. *Invert perspective.* The instinct to balance what the eye sees with what the mind knows affects almost all art. Invert perspective accepts the fact that things near are smaller than "out there."

The good thing about linear perspective is that it creates a sense of depth into which more shapes and colors may be packed; the bad thing is that these holes and bulges rupture the surface, disturbing its decorative continuity.

Opposite page:
Abbreviations—
E. L. = eye level
P. P. = picture plane

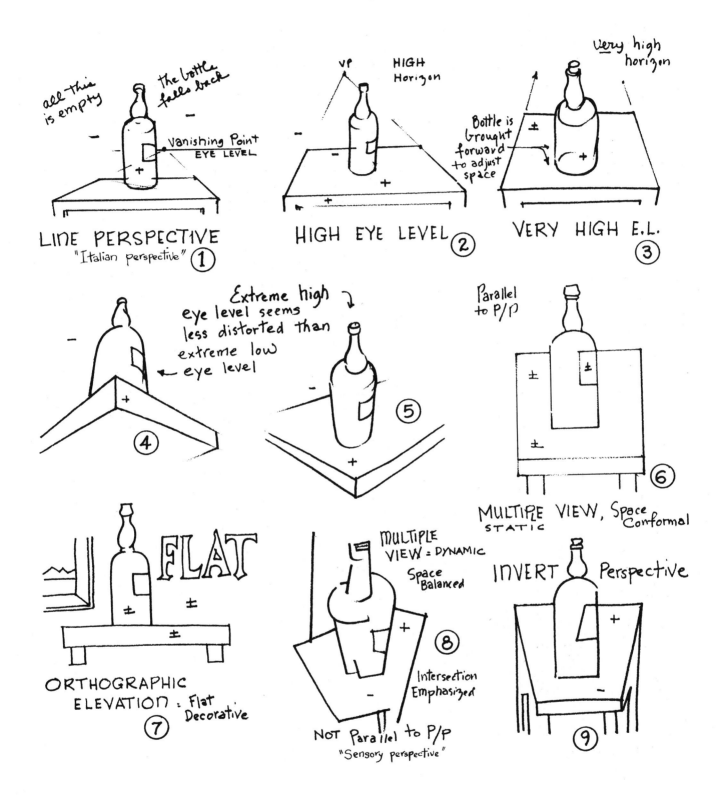

all this is empty

the bottle falls back

Vanishing Point
EYE LEVEL

LINE PERSPECTIVE
"Italian perspective" ①

VP

HIGH
Horizon

HIGH EYE LEVEL ②

Very high horizon

Bottle is brought forward to adjust space

VERY HIGH E.L. ③

Extreme high eye level seems less distorted than extreme low eye level

④

⑤

Parallel to P/P

MULTIPLE VIEW, Space Conformal
STATIC ⑥

FLAT

ORTHOGRAPHIC ELEVATION: Flat Decorative
⑦

MULTIPLE VIEW = DYNAMIC
Space Balanced

Intersection Emphasized

NOT Parallel to P/P
"Sensory perspective"

⑧

INVERT Perspective

⑨

There is no such thing as starting where Cezanne left off. You have to start where he started . . . at the beginning.

—Kimon Nicolaides

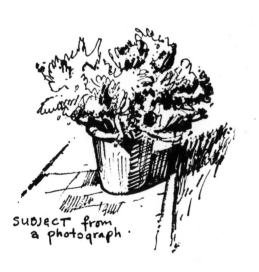

SUBJECT from a photograph.

Intersection/Overlap

As old as the cave paintings of Spain, the creation of the illusion of space by linear intersection and shape overlap still seems to baffle many who attempt it. The following exercises help master this constructive approach. Here are two general suggestions for proceeding with them:

A. Instead of visual rays and foreshortening, adopt the attitude of a sculptor, imagine each lapping plane as a thin piece of wood. Progress from near to far, tucking each behind the preceding one.
B. Choose any subject, but preferably one rich in shapes. (A single lonely tree in a desert vastness would be difficult, but not impossible.)

Experiment 1.

Imagine that you are building a shallow sculptural relief using rectangular playing cards. Place the first rectangle on the nearest surface; tuck additional "cards" behind it, working back in depth until all the space is defined.

Experiment 2.

With brush or felt pen, underscore the points of intersection (the *nodal points*) in the above. Then with a fresh sheet of paper, draw the subject this way. Note how the result is fluid and shapes open to each other.

Experiment 3.

Try modifying the cubistic appearance of the previous study with suggestions of texture—for example, a scalloped line to suggest foliage, a straight line for the pot.

Experiment 4.

Finally, emphasize the major shapes in comparison to the minor clusters of foliage, and underscore the nodal points.

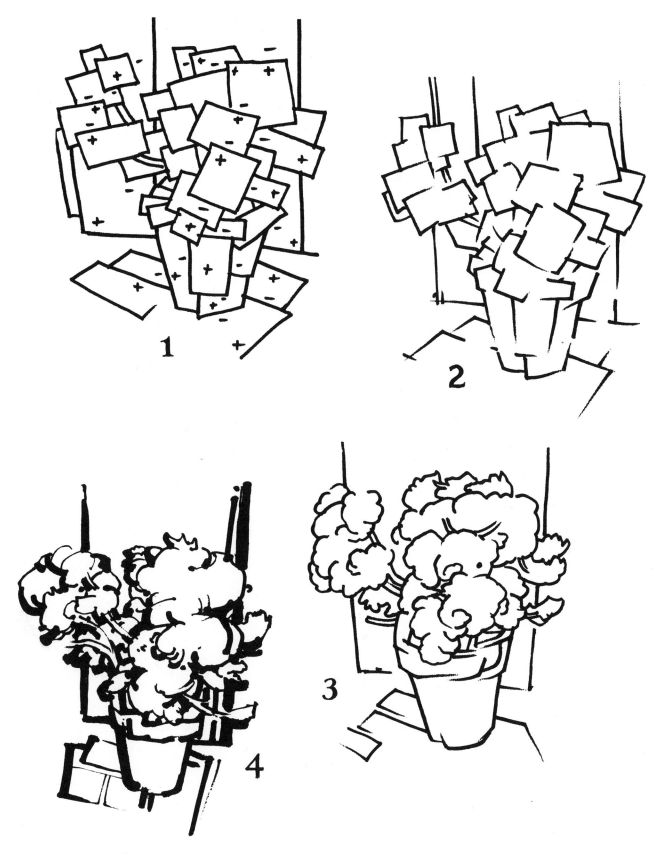

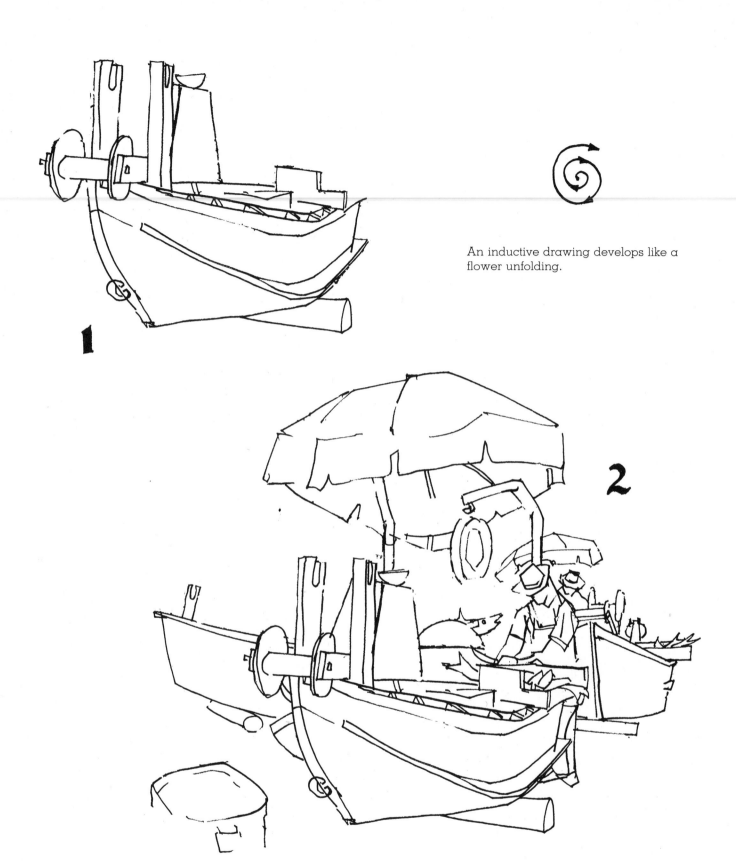

An inductive drawing develops like a
flower unfolding.

Exploring Relationships with Inductive Line

To strengthen awareness of shape and space, practice drawing inductively—no preliminary outlines, gestures, or contours. Select an intriguing foreground relationship, and place it near the center of the sheet. (In the example, the roller at the bow of the near dory.) Use a felt-tipped pen or India ink to discourage the instinct to erase.

Proceed to tuck line behind line, spiraling outward from the first overlap. If a shape appears isolated (the umbrella for example), search for subtle folds in the clouds, earth, or other flat planes to provide a shape which will serve as an intermediary.

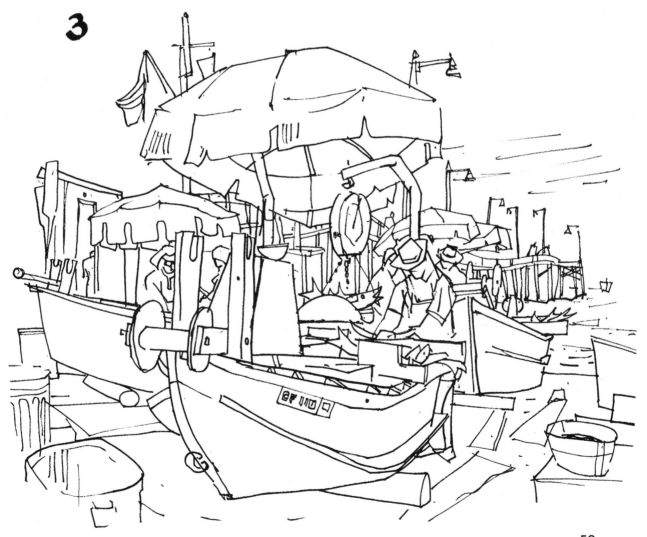

Summary: the Painter's Line

A. Layout lines divide the surface into major divisions. These shapes may in turn be divided into minor or secondary units.
B. Learn to underscore the major divisions and shapes, leaving shape-in-shape, texture, and color to develop later in paint.
C. Define space intervals by strengthening the nodal points, the meeting places of line against line.

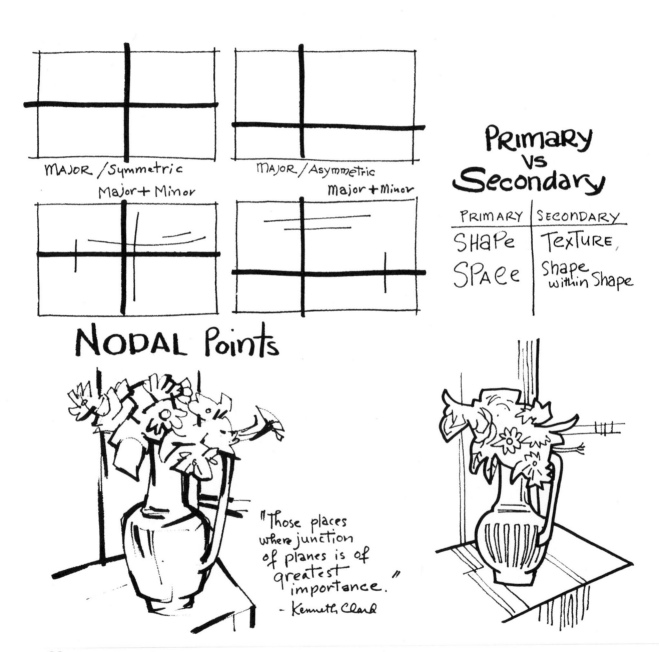

MAJOR / Symmetric
Major + Minor

MAJOR / Asymmetric
Major + Minor

PRIMARY
VS
Secondary

PRIMARY	SECONDARY
SHaPe SPaee	TeXTuRe, Shape within Shape

NODAL Points

"Those places where junction of planes is of greatest importance."
— Kenneth Clark

Steps from Line to Paint

A. Investigative drawing uses gesture and contour drawing to become acquainted with the subject.
B. Relational drawing explores the effect of each shape on the next.
C. A line and wash, "thumbnail" drawing tests the idea in terms of format and value.

A

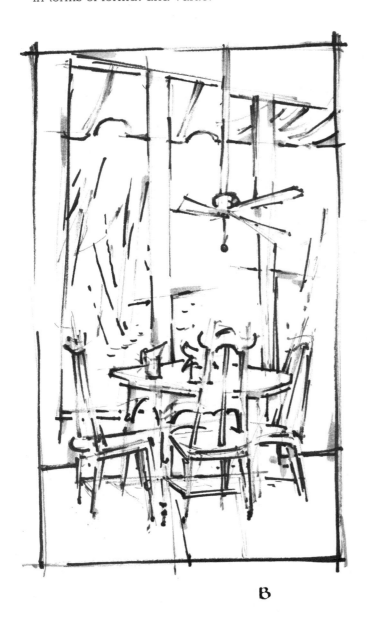

B

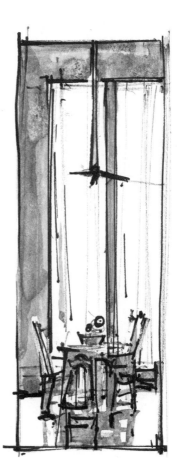

C

Experiments with Line

Perfecting the Painting Layout

No matter how much you like the first study, it can be improved! Turn it upside down. Look at it from a distance. Examine it reversed in a mirror. You will discover unneeded bulges, distortions, and shapes.

To make improvements without losing what is satisfactory, overlay the drawing with a piece of transparent tracing paper. Trace the best parts with a soft pencil, moving the overlay sheet around, if necessary, to better relate each part to the next. Concentrate on shapes rather than subject matter.

Now, "clean-up" the overlay with a second sheet of tracing paper. Don't hesitate to institute further improvements. You may use a good many sheets before the composition is completely satisfactory.

Identify the Dominant Rhythm and Feeling (pages 36-37).

Newspaper photographs provide good subjects for this exercise. Choose pictures with a variety of shapes—a group of people, football action, a wreck—rather than a single object. Make three separate tracings, drawing with a decisive, firm line: (1) all the verticals and horizontals. (2) the principal diagonal and one or two others, repeating each as often as it can be found. (3) the principal curve and one or two others with their repeats.

Proportions of the Format (pages 38-39).

Pencil-in three formats on one sheet of paper—a square, a vertical rectangle, and a horizontal rectangle. Then select your subject, something informal like the corner of the studio or a still life. Draw the subject to fit each of the formats. If necessary, modify the format to better accommodate each drawing.

Create a Symbol Language (pages 40-43).

With a felt pen and a large sheet of paper, develop a catalogue of *linear hieroglyphics*, recording objects around the studio. Try to reduce each to the fewest possible strokes. Draw as if describing the object with gestures of the arm. Try different viewpoints until you find the most revealing one.

You will find inspiration by studying the symbol language of others; the Egyptians, cartoon comics, Raoul Dufy, and the Oriental arts, for example.

Articulate Drawing (pages 42-43, 60-61).

Learn to underscore the important parts of your drawing by the use of a tissue-paper overlay. Place it over a drawing and, with a brush or felt-tipped pen, make a selective tracing, picking up the nodal points and the major space divisions and ignoring everything else. Execute each stroke quickly, turning the paper if necessary to accommodate the angle of the stroke. Hold your instrument nearly vertical and draw with wrist and arm rather than fingers, keeping every line as geometric as possible.

Tension (pages 44-45).

Dramatize your previous line studies by tensioning line against line. Use tissue-paper overlay and pen or brush to redraw, exaggerating angles, intersections, and directions. Try to make the whole drawing appear to warp and rock as if in an earthquake. Leave out any line that will not cooperate.

Silhouettes and Configurations (pages 46-47).

Our goal: More with less.

Draw the outline (contour) of two or more objects as one continuous shape. Keep the enclosed area as simple as possible. Reduce changes of direction to a minimum. For example, indicate a stairway with two or three treads rather than a dozen. Use a felt-tipped pen, working slowly and contemplatively. Consider the negative surround as often as the configuration itself.

Standpoint (pages 52-53).

Without referring to the actual object, draw a box in the following positions: (a) below eye level, (b) at eye level, and (c) above eye level. Assume that each box is seen at arm's length. Next, draw the same three views as if the box were across the room. You may need to draw perspective projection lines at first, but practice until you can do without them.

Now test your visualizing ability: Draw a kitchen chair located a few feet away and below eye level. Without changing position, proceed to draw the same chair as if it were in the air above your eye level.

Controlling the Illusion of Space (pages 54-55).

Select one of the previous drawings and proceed to manipulate positive-negative shapes in each of the nine ways illustrated on page 55. Don't be frustrated if you can't accomplish them all. Proceed with the lessons which follow, especially those on pictorial composition, and then try again.

Space by Overlap (pages 56-57).

Commence with a pencil drawing of any solid subject—something which will stay still for prolonged study, such as a tree, a still life, or an architectural object. Overlay the drawing with tissue paper and develop three separate analyses, placing tissue on top of tissue.

1. A "playing card" study of overlapping planes. Commence with a rectangle to represent the nearest surface and proceed to tuck plane behind plane, working from near to far.
2. With a fresh overlay, trace selectively, emphasizing the nodal points and primary lines. Avoid closing any shapes. Keep the entire surface an open mesh of intersecting lines.
3. Repeat the previous overlay drawing but with

linear variety—curves and angles—to describe the subject in a more literal way.

4. Go back to the original pencil drawing and ink it down—reinforcing the main divisions and intersections and ignoring the minor divisions. When the ink is dry, erase the pencil lines.

A Daily Exercise (refer to examples)

Practice shape relationships daily, drawing on anything, anytime—on a napkin, on the edge of the daily paper or, even, on the sand with a stick. Three block letters are sufficient for shapes. Your name or initials, for example.

1. Overlap each letter from left to right.
2. Overlap each letter from right to left.
3. Make all letters equivocal (transparent).
4. Arrange them as conjunctive shapes.
5. Make them into a configuration.
6. Create an optical jump within each letter shape.
7. Make the letters appear to recede from left to right.
8. Make the letters appear to recede from right to left.

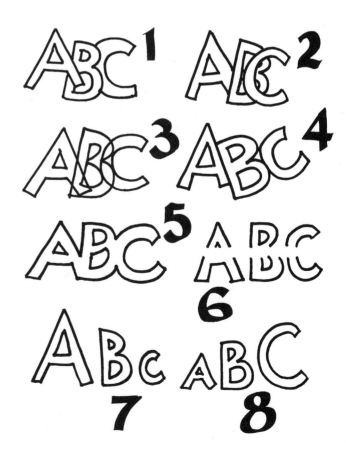

Value:
Relative lightness or darkness of a pigment or of light and shade.

There are bigger things to be seen in nature than the object, for objects are absorbed through light and shade or color to create larger, more interesting shapes.

We *see* light, not dark. But it is in the darks that we *feel* goblins and ghosts.

All the greatest exponents of civilization have been obsessed by light . . . perhaps one could take light as the supreme symbol of civilization.

—*Kenneth Clark*

To paint under the canopy of sunlight is to see things larger than life, to feel capable of a certain heroism.

PART III
VALUE

Hue, value, and intensity are the primary characteristics of color but, because the delicate photoreceptors of the eye vary greatly in perceptive ability, there is an extraordinary lack of agreement about what color is. Only those nerves which measure amounts of dark and light respond in the same way for all of us. No wonder that the painter organizes his painting procedures and views his subject in relation to value.

The role of value is so basic to color planning that artists have said for centuries, "If tone is right, color doesn't matter." But it was only recently that it was finally scientifically proven that intervals of black, white, and gray can substitute for wavelengths of color. In 1959, Dr. Edwin Land, inventor of the Polaroid camera, published the results of experiments undertaken as a part of the development of color film: the experiments verify that value can provide color sensations *even when hues are positively absent.* "That is a rather colorful statement, will you please put it in black and white?", is typical of the vernacular of our times. Translated, it implies more faith in value than color. We simply don't trust our color perceptions—or those of others!

Even value relationships vary, however, depending on the strength of surface lighting and the comparison of one tone to another, so the artist must be selective in adopting a value system which will carry through his work and support his colors.

In view of the above, it comes as no surprise to realize that most artists separate the painting development into two steps: first, value, whether as a preliminary sketch or as underpainting (grisaille); then color, as overpainting (glaze) or mixed directly with blacks and whites to achieve both color and value at one stroke *(alla prima).*

Regardless of how one proceeds, there is no such thing as copying nature, for the eye/mind perceives several kinds of value patterns at the same time—as discussed on the following pages. Any one concept can provide the basis for a valid pictorial statement. All together they can be chaos.

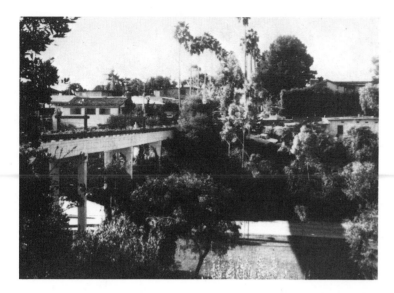

What the Eye Sees

A black and white photograph of the subject is a compromise between light intensity, local color/value, and halation (inducted value).

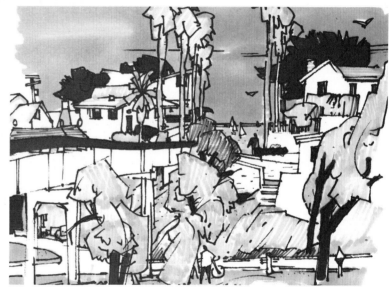

Local value, the inherent value of the surface of an object, contrasts with light/shade. Example: the white bridge.

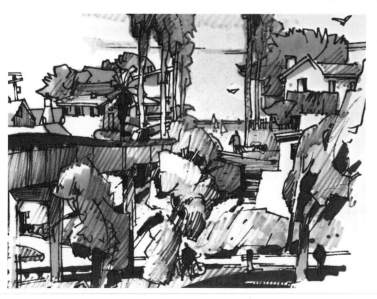

Atmospheric value (aerial perspective) causes the distant trees to have less dark/light contrast than the near ones.

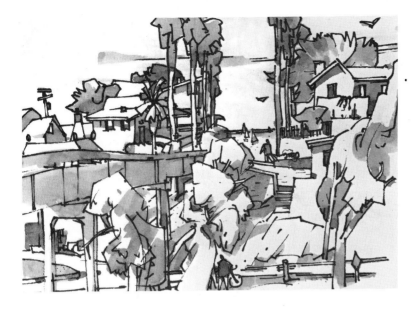

Sidelight divides the trees into black and white in comparison to local value, which sees them as various grays.

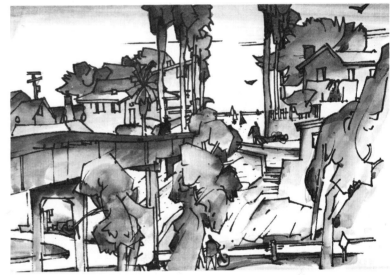

Backlight, in this example, created by the luminosity of the sky, causes the distance to group as a silhouette.

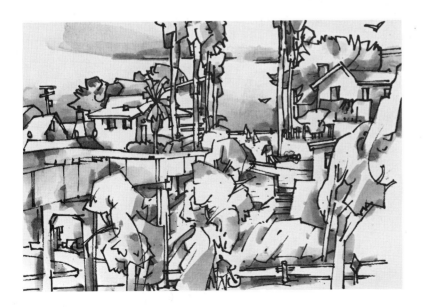

Simultaneity, forces values to opposite extremes where shapes meet.

Developing an Iconography
Based on Dark/Light

To speak a consistent value language, the painter has to adopt a viable dark/light scheme. It may be based on the objective patterns measured by the camera or on such subjective influences as abstract (formal) tone or feeling. His audience will follow him regardless of the choice as long as he is consistent. Frustration is the common lot otherwise.

For example, the layman can "read" Michelangelo's sidelighted imagery, the internal luminosity of El Greco, the simultaneity of Cezanne, and the emotional patterning of Nolde equally well because each artist establishes a scheme and maintains it.

Over the years I have observed, in both my own work and that of my students, a dichotomy about light which seems to make the development of a graphic vocabulary challenging indeed: the concept of a painting as a window—or better, a doorway—versus the idea of it as a mirror. The doorway view with its implied internal lighting seems appropriate for mood. But, if the wish is to describe the physical appearance of things, replication of an external system of illumination seems better. The first concept provides a way to make the painting appear to glow from within. The second replaces luminosity with the appearance of applied light, illumination.

Luminosity and illumination in painting have vied for supremacy for centuries, as exemplified by the history of Western painting. The internal lighting of Byzantine art shifting to the external lighting of Tiepolo and Rubens, culminating in Impressionism. Post-impressionism returned to light as inherent in the painting and established the basis of most twentieth-century art. Now photo realism is causing the pendulum to swing back to exterior lighting.

Value Systems Compared

 Front Light

Eastman Kodak advises the color photographer to shoot his subject in *full light*, i.e., with the source of illumination at the photographer's back. This reveals local color and texture best but at the expense of dark/light pattern. Because of the emphasis on local color, full lighting is a good choice for factual illustration and the advertisement of objects as separate entities.

 Back Light

The antithesis of front light is silhouette-making back light. Identity is absorbed into the overall configuration of dark against light. As one veil-like silhouette overlaps another, halation occurs, causing each layer to gradate. This creates movement, like an arpeggio in music, which is exciting.

Because the source of light appears to be within the frame, the design appears more luminous than if the lighting were from outside.

Examples: Chinese landscape painting, the luminists.

 Side Light

For hundreds of years, Western art has used directional lighting to indicate volume by dark and light "shading." The problem with such modeling is that shapes are split, which may not be understandable or decorative. Also, color is reduced to tints and shades.

Example: Michelangelo.

 Toplight

A variation on sidelight, toplight borrows something from back light to return the apparent source of light to the picture's interior. Shapes are isolated pools of light and puddles of shadow. Illumination from above creates a mysterious, solitary, and spiritual sensation.

 Local Tone

As an attribute of local color, local tone (value) aids the painter in the identification and simplification of objects. A light gray may suggest yellow; medium gray, green; dark gray, purple; and so on.

The random patterns of local color are not an easy basis for value selection but, when used with selective restraint as in the block prints of the Japanese or Gauguin and the posters of Toulouse-Lautrec, the effect is powerful.

 Inducted Value (Simultaneity)

When different values are juxtaposed, their differences are exaggerated. The camera records this as halation. The human eye sees it as simultaneous contrast.

The phenomenon is extraordinarily useful to the painter because it provides a basis for indicating value relationships without destroying pictorial luminosity or precluding color.

Example: Cezanne.

 Formal Tone

When we choose a black belt to go with a white dress, or a white handkerchief to tuck into a dark coat pocket, we are responding to an abstract need to relate values. In the same way, the painter is impelled to orchestrate values to advance the checkerboardlike rhythms of the painting, regardless of content.

Example: Mondrian.

Emotion

A need to express one's feelings may be so great as to override any other consideration, causing the painter to squeeze light out of dark like a scream in the night. Goya's moody "Black Paintings" and the art of Nolde, Munch, and Kollwitz are examples.

Front Light

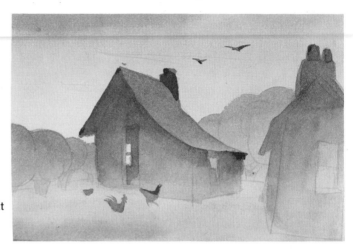

Back Light

External Light

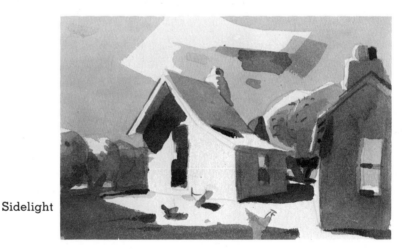

Sidelight

Light from Without

Top light

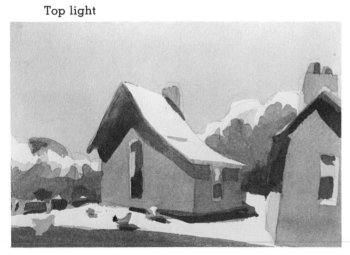

The concepts on this page are based on objects illuminated by a single, exterior light source. Compare them to those on the opposite page, which are not based on directional lighting at all.

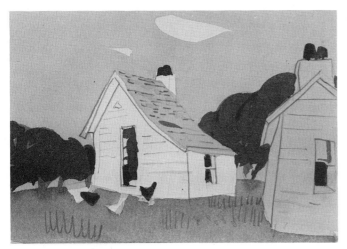

Local Tone

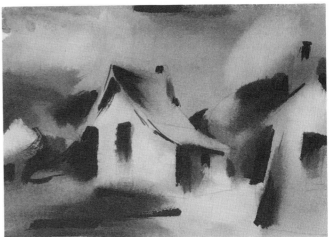

Inducted Values

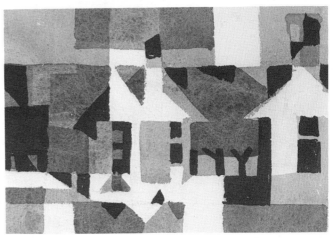

Formal Tone

Emotion

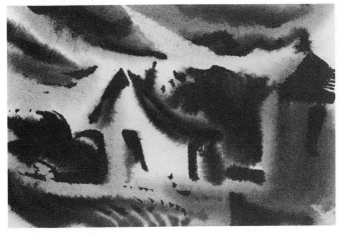

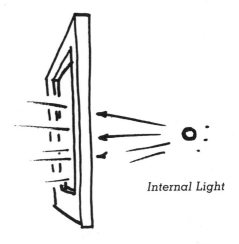

Internal Light

71

Simultaneity (Simultaneous Contrast or Induction)

What It Does

When two colors or values are juxtaposed, differences are exaggerated at their meeting point, causing them to appear to move toward opposite extremes (polarity). For example, a light gray against a dark gray will appear even lighter; a red against a gray will cause the gray to appear green, the complement of red. The camera records the phenomena as halation, an edging of intensified dark against the lighter shape.

Painters have used simultaneity to extend the apparent range of their pigments since the times of Titian and El Greco, but it remained for Cezanne to employ it as the basis of pictorial organization.

Why Simultaneity Is Important to the Painter

1. It supplies the same sort of plus/minus logic to visual relationships that the electronic computer provides to scientific evaluations. In this way it doubles the potential of the picture, as every square inch is set to work. Except in a relative sense, the sign (−) negative ceases to exist. Everything is positive!
2. The sensation of *gradation* which is induced causes planes to appear to tilt or wedge against each other, contributing to the liveliness of the painting.
3. *Counterchange*, the result of the increased contrast at the boundaries of shapes, strengthens the rhythmic alternations of shape against shape, endowing the design with a heartbeat.

Of two objects equally light, one will appear less so if seen on a white ground; and, on the contrary, it will appear a great deal lighter if upon a space of dark shade.

—*Leonardo da Vinci*

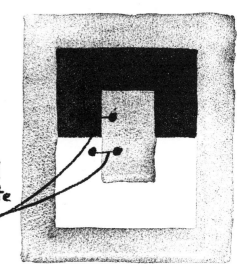

example = INDUCTED VALUE : a gray is induced
to appear lighter against black, darker against white

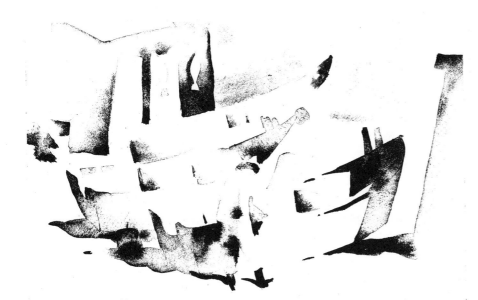

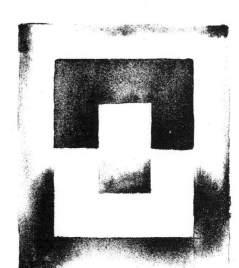

─ GRADATION ─

─ COUNTER CHANGE ─

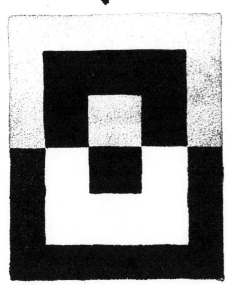

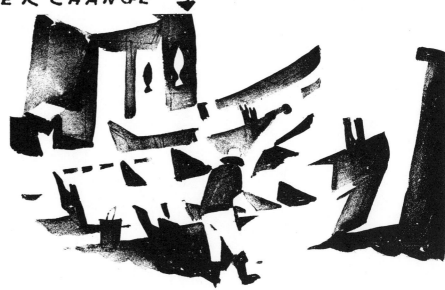

Configurations and Counterchange

New Patterns from Old Things

Creativity has become synonymous with invention and novelty these days at the expense of appreciation and understanding. So much so that the painter feels required to ignore the warmth of sunlight, the coolness of shadow, the kaleidoscopic rush of color along the road, as truisms. But in doing so one overlooks the ultimate truism, that nothing is new under the sun.

If the painter will start looking, *truly looking*, he will discover an unending series of new visual relationships, visual gestalts, or configurations. Derived from the mundane, these relationships can acquire a magical new quality when seen as one.

The famous surrealist *Fur-lined Teacup* is an example. Two banalities, fur and a cup, are placed in a new (configurative) relationship. The result: a startling image to challenge the eye.

Study the fishboat on the opposite page. Not too exciting. Combine it with its reflection, and the image is more arresting. Combine fishboat, reflection and a rocky shoreline into one configuration, and a new experience occurs.

Seeing Things As Configurations

1. *Counterchange* can cause a grouping of shapes as one dark (or light) figure (opposite).
2. *Surface similarity* of value or color can relate different figures as one, as is demonstrated with the fishboat.
3. *Passage*, the flow of light across several objects without interruption, will unite them as one. The light pattern on the mountain peaks (opposite) is an example.

Gestalt:
An integrated structure or pattern unique and complete—not just a sum of parts; a configuration.

There's a thrill in discovering new patterns in familiar surroundings!

74

effect of counterchange

1 Fishboat = a type

2 Fishboat
 +
 Reflection
 = a Gestalt

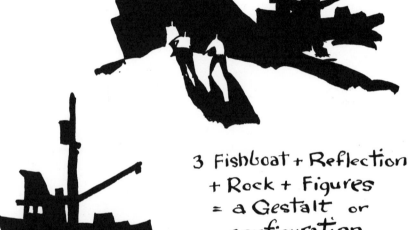

3 Fishboat + Reflection
 + Rock + Figures
 = a Gestalt or
 configuration

effect
of passage

75

Passage

If counterchange can be compared to the beating heart, passage is analogous to the system of arteries and veins serving every part of the body. Its flux and flow unifies shapes, breaking barriers and challenging perception.

"Lost and found shapes" describes how passage appears but not its integrative function as linkage, connecting the parts of the composition like a "palpitating conglomerate."

To see passage, the painter must overcome an instinct to individuate. Instead of focusing on separate things, he must seek bridges and channels of continuous light.

Obsessed by the power of nature . . . not its form . . . Turner saw light as the supreme unifying force.

Passage: Easy to understand but difficult to see!

—Joan Irving

Passage: atmospheric fluidity, the way from realism to poetry.

—André L'Hote

Opposite page:

Version 1.
The watercolor of the Pueblo at Taos looks like the rendering of some old shoes. The parts are all there, but it lacks decorative unity.

Version 2.
By weaving an uninterrupted zigzag of light from the top of the sheet to the bottom—passage—all is unified. Another passage runs from the upper left to the lower right. These *pathways* cause the dark patterns to group in contrast. The result, a chiaroscuro of dark/light.

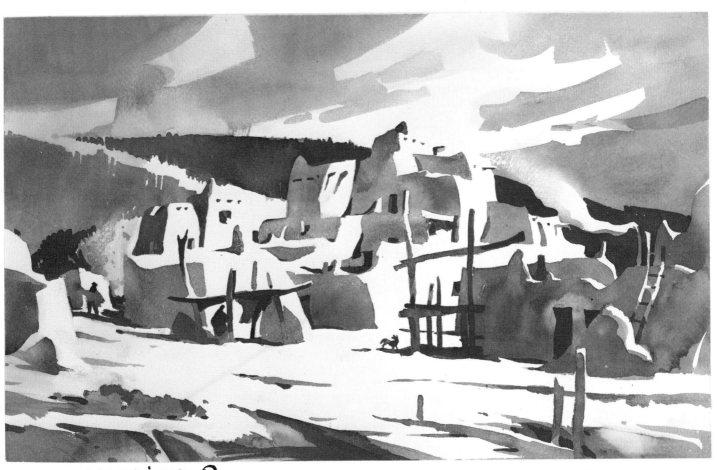

version 2

passage

version 1

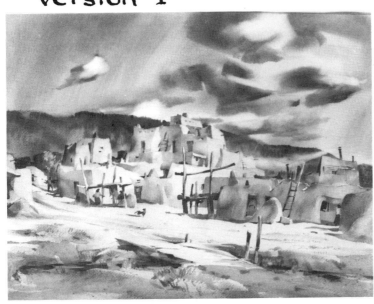

Feel positive (the whites), paint negative (the darks).

interweave

Interlocking Lights and Darks

Like a clutching hand, dark shapes shrink and hold light. Regardless of the addition of colors or textures, the opposite is impossible. Because of this, the artist weaves his darks into his lights like a basting of stitches. This explains why darks integrate into the design more securely when they are shaped like the letters "L" and "U" and are turned to open inward.

No eye sees dark—it is the absence of sensation. It is the dark alleyway, the tunnel mouth, the bottomless pit; goblins and ghosts are here. This transmogrifying power of blackness invites the imagination and is a part of the secret appeal of the painters of chiaroscuro such as Goya, Rembrandt, and the twentieth-century New York School's Motherwell and Still.

Another characteristic of the darks is spatial: they recede while the lights appear to advance. The effect is greatest when the darks are aligned and thus appear to weave through the design, as demonstrated here.

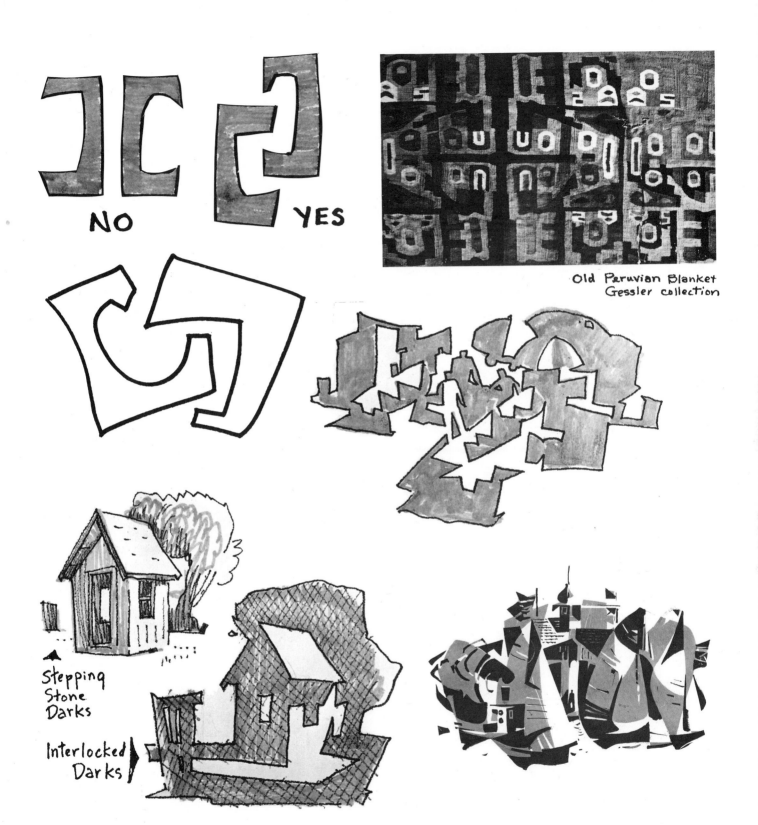

NO YES

Old Peruvian Blanket
Gessler collection

Stepping
Stone
Darks

Interlocked
Darks

Chiaroscuro

A. Traditional Chiaroscuro

For centuries painters employed light and shade from a single direction to unify the parts of their design as well as to explain the angle of one plane to the next. The resulting effect is decorative, although rigid and static. Light appears superimposed on the subject rather than intrinsic.

B. Cezanne's Chiaroscuro

The web of dark/light pattern is created by value or brightness comparisons, causing the canvas to appear lighted from within as if by countless tiny candles at each conjunctive point. This is the source of the luminosity of El Greco and the Chinese landscape masters. It is the essence of Cezanne and the cubists.

C. Sunlight and Simultaneity Reconciled

Although most twentieth-century painting achieves its luminosity by a pattern of induced lights, it is possible to reconcile this viewpoint with that of directional light as is here demonstrated. Many popular painters and illustrators combine light/shade with simultaneity in this manner.

Example: Edward Hopper.

Chiaroscuro:
Treatment of light and shade or brighter and darker masses in a picture.

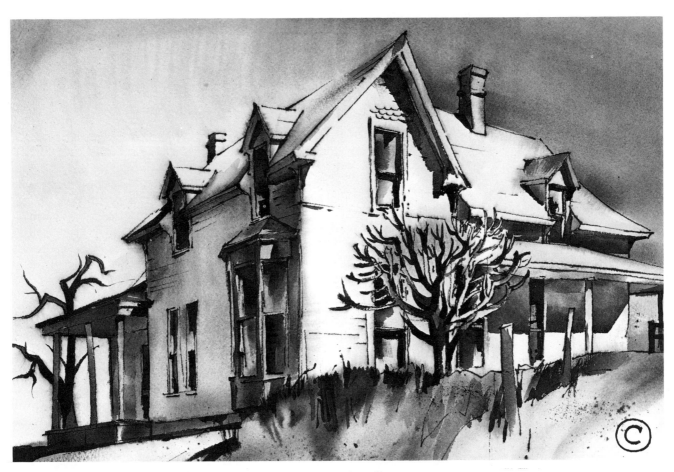

(C)

Sources of CHIAROSCURO

definition = Dark / Light pattern

FLAT CONTRAST based on
Sunlight and local color
examples: Tiepolo, Caravaggio, Kline

(A)

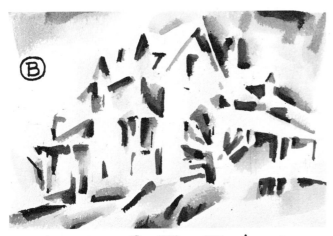

(B)

GRADATED CONTRAST based on
INDUCTED VALUE. examples = Cezanne,
Titian, Marin

81

Attention by Contrast

Imagine that you are viewing a landscape on a day of mixed clouds and sunlight. At one moment the sun illuminates a distant hilltop, causing it to gleam above a leaden sea. In the next, the sea bursts into light and the hill shrinks into shadow. Extreme light and its ubiquitous companion, great dark, draw the attention first; then the less extreme intervals of contrast are seen.

The versions of *Tomales Bay* (opposite) demonstrate how the artist can exploit and direct attention by controlling chiaroscuro. Observe how the eye goes first to the points of greatest dark/light contrast.

It helps to think of the middle gray intervals as the *amalgam* which unites color and textures and causes these to resonate one against the other.

Hierarchy of Attention

The eye is directed to the value extremes first, Number 1 (white) versus Number 4 (black). Next it goes to the intermediate relationships, Number 1 (white) versus Number 3 (dark gray), and Number 2 (light gray) versus Number 4 (black).

An Important Corollary
Notice how the lighter values appear to advance, the darks to recede, regardless of their apparent position in space. The painter soon becomes aware of this up/down function of value and learns to control it.

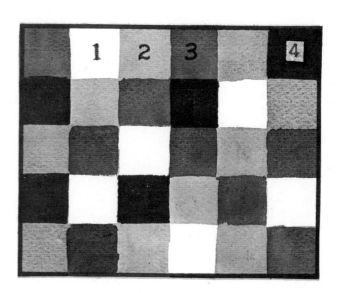

Shifting Emphasis

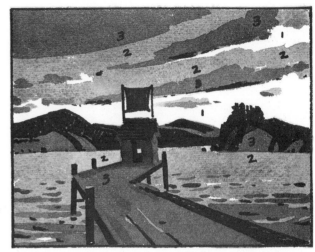

Sky

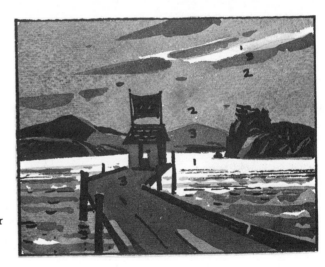

Water

Pier

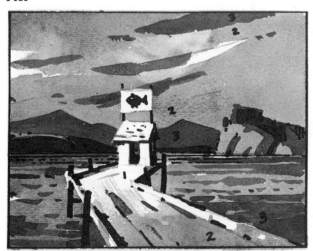

83

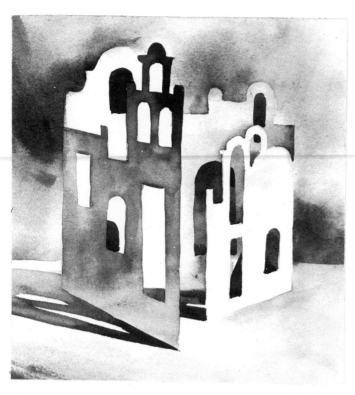

Line,
Shape,
and Value
Reviewed

Painter/teacher Joan Irving uses white paper constructions as a way to study intersection, overlap, and simultaneous contrast of value.

The examples are small, castlelike cutouts made with heavy paper which is folded into three or more planes. A single source of light provides light/dark contrast. These are watercolors; they could be in any medium.

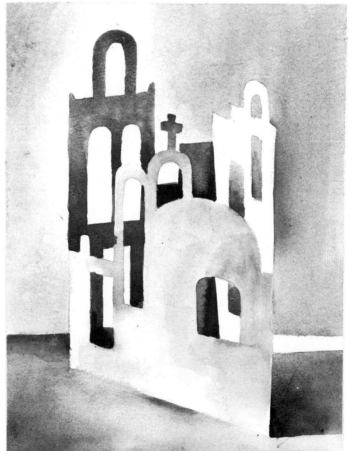

Experiments with Value

Configurations (pages 74–75, 78–79).

Our goal: a web of magical, big, interlocking shapes of light and dark—shapes which beckon and leave part of the story to the audience.

An easy exercise to be practiced daily—use a felt-tipped pen or a watercolor brush or black paint, and edit the photographs in the daily paper, grouping the dark shapes into geometric units. If a particularly exciting pattern unfolds, pick it off with tracing paper and make a wash drawing.

One of our students has her pupils use such patterns as the basis for abstract painting, with extraordinary results.

Passage (pages 76–77).

Analyze your paintings for flow of dark/light by making a series of small studies in one or both of the following techniques:

A. Commence with a black field or surface and paint the pattern of light in opaque white, or, better, cut this pattern out of white paper and glue it to the surface.

B. Paint as in watercolor, commencing with a white surface and creating a system of corridors or passageways of black. We like to use a broad black felt-tipped pen for this experiment as it keeps us from excessive detail. If the design needs improvement, paste pieces of white paper over the areas concerned or start another test.

Chiaroscuro (pages 80–81).

This experiment can be a continuation of the one above. The goal, to add movement by gradation from light to dark. Once the subject is examined as flat pattern (example A, page 81), explore it for gradated value as demonstrated in example B. Finally, do a third study reconciling pattern and movement, as demonstrated in example C.

Ways with Value (pages 68–71).

Select one subject and pencil or ink its main shapes onto eight small canvases or, if watercolor, sheets of paper. The subject should have enough volume and shape variety to accommodate the versions demonstrated on pages 70 and 71. Some we find challenging include a model partially draped in folds of cloth, a group of shacks or similar buildings, a still life of fruits, vegetables, or other simple solids displayed on crushed newspaper.

Five of the exercises stress flat tones and should be tried first, using no more than four values ranging from black to white. They are: front light, sidelight, toplight, local tone and formal pattern.

Back light, inducted value, and emotional tone require gradation of value.

You will favor one or another of these viewpoints, no doubt, but endeavor to distinguish each from the next, in this way developing flexibility with shapes and images.

Attention by Contrast (pages 82–83).

Although this experiment works equally well with formal pattern or nonobjective subjects, start with a subject in full sunlight.

Make four tracings of your line drawing, then experiment with values. Paint a light gray over the entire sheet except for one or two target whites—varying the selection for each study. Paint in flat tone, no gradation, to keep the studies strong, clear, and decorative.

Next, place blacks cautiously against the most important whites only. Now you may proceed to a deeper gray, inspired by shade and shadow areas. Additional blacks can be introduced into this dark gray for explanation or decoration.

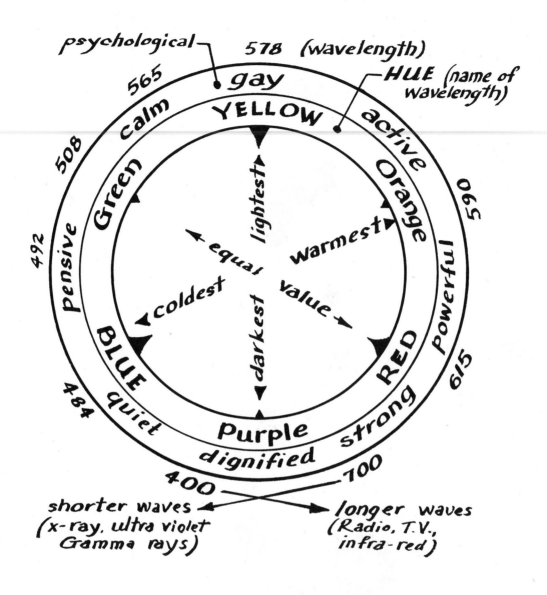

Color Spectrum

Primary Colors

Physical (Light): green, violet, red.

Pigment: yellow, red, blue.

Psychological: yellow, red, blue, green.

COLOR
AND TEXTURE

Enjoying the interplay of color with color is one of the great thrills of seeing—and the least understandable. We know what we like but we are surprised at our friends' choices. We become aware that different sources of color affect us differently—the hues of a rainbow or a sunset sky beguile some; the surface pigmentation of an apple or an orange, others. Some prefer carefully arranged harmonies, others the tension of pigments flung on canvas with feeling.

The painter, as spokesman for what the eye perceives, must be aware of all the potentials of color. But, his success lies with the adoption of a viewpoint within which his pigments may function. It comes as something of a surprise to discover how restricted this limitation is in most masterworks, whether those of Rembrandt or Matisse, Giotto or Picasso. (Both Picasso's famous *Guernica* and Matisse's Chapel murals at Vence are virtually colorless.)

As with value, we will accept an extremely limited color concept as long as it is consistent. This may explain why cartoon comics and colored photographs are both popular and completely understandable. In both cases the restrictions are caused by mechanical limitations which effectively discipline the cartoonist or photographer. This is not so true of painting, which is capable of a greater flexibility in recording color both as perceived and as an expression of individuality.

One learns about color by *looking, looking, looking!* Seeing color means recognizing the many ways it can appear at the same moment. For example, an apple can appear red (its local color), orange in sunlight, and purple against an orange background, simultaneously.

The painter must single out which manifestation is best suited to his statement, and then subordinate all others to it.

Color is the language of poets. It is astonishingly lovely. To speak it is a privilege.

—*Keith Crown*

The untrained eye can distinguish 17,000 colors; the trained eye, 27,000.

To use color well is as difficult as for a fish to pass from water to air or earth.

—*André L'Hote*

Color Perception: What We See versus What We Think We See

To see, *really see*, color requires discipline, for we are all perceptually blind, trapped by a primitive need to identify things by their local or surface pigmentation. Even a camera "sees" more. Like a child, we *know* that all skies are blue, trees are green and the earth is brown. Even the otherwise skilled painter succumbs to what he *thinks* he sees rather than what his eye perceives. (Have you noticed how many golden sunsets are shown above blue water?)

Test your ability to see color by studying the four flat colors on the opposite page, top. See if you can separate what you *think* you see from what you really see by making the following *visual* comparisons.

1. Curl the page to make a half-cylinder. Study the four flat local colors with the light striking the sheet from one side. Can you see the changes in the green border? Depending on the kind of lighting, they will appear to go all the way from yellow to blue green. This is the effect of the *temperature of light*.

2. With the page flat, study the central red-orange shape. Compare it to the right against blue, to the left against yellow. Can you see the differences? It will seem to complement the adjacent color, appearing more yellow against the blue, more purple against the yellow. The other colors are influenced in the same manner as illustrated in the second example. This is the effect of *simultaneity*.

By learning to see color objectively the painter expands his visual vocabulary. Values relate, objects belong to each other, color is freed to describe space, movement, and emotion.

Local Color
Four flat colors are related. The mind tells us that these are ungradated, "solid" hues.

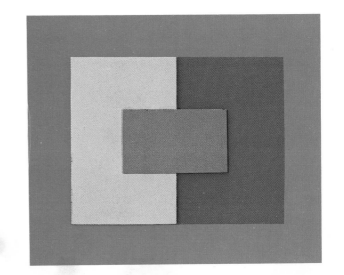

Perceived Color
This is what the eye sees when looking at the above example. First, note value differences (refer to pages 72–73): Next, observe how colors are *induced* to move to polarity where they meet.

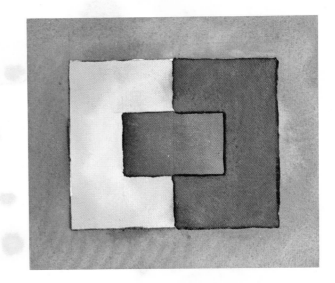

Inducted Color
When color is freed from the object to work relationally (in this example, a red barn) *things* cease to exist and the whole painting becomes decoratively exciting.

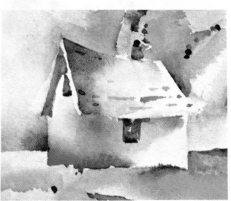

89

Mix and Match

Color is everywhere. No need to chase to some remote South Sea atoll to find a feast when it exists in your own backyard!

Learn to see by practicing this exercise in mix and match (the procedure is similar to the lesson on inductive drawing, pages 58–59). Select a starting point, in this example, the brick chimney, and set shapes against it, working outward. Compare hues by asking yourself, "Is it redder, or greener?" "Does it appear as yellow, or blue?" and so forth. Mix a swatch of pigment and put down even the suspicion of an answer.

Don't draw too many preliminary lines. Don't plan or focus too hard on anything. Study the interface of color against color with dilated eyes, as if looking at a loved one. Avoid fancy brush work, put down your discoveries in notebook style.

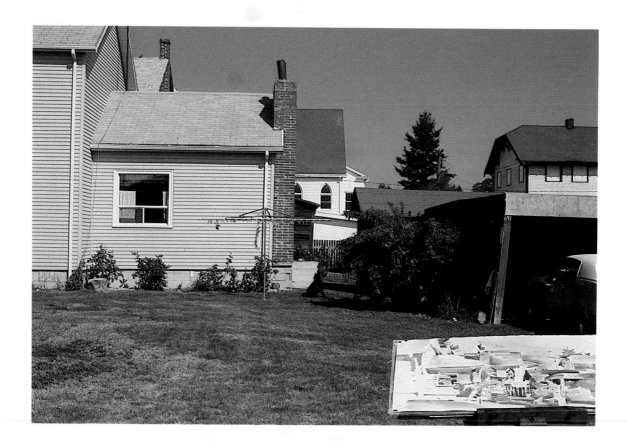

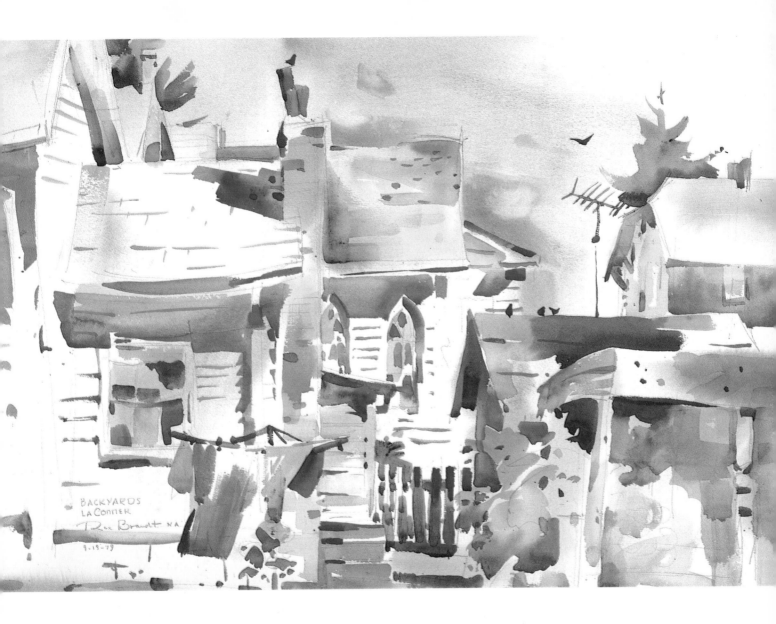

Opposite page:
A portion of a mix-and-match study
in watercolor based on the subject.
Note how large shapes have been
compressed to intensify color
comparison.

**Color photograph of the subject by
Art Hupy.**

The Many Ways of Seeing Color

Local
The surface pigmentation of an object, *green* tree, *blue* sky, *brown* ground, *red* house. Useful for identification. Difficult to adopt as a color motif.

Atmospheric
Distance causes colors to appear grayer and bluer (aerial perspective). Useful to suggest depth.

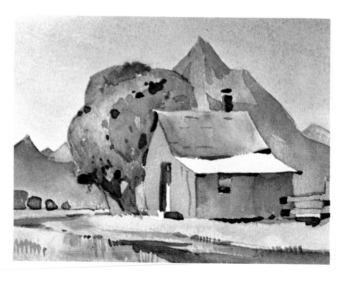

Light/Shade
The color of light affects all that it strikes. Sunlight is warm; the northlight of a studio, cool. Useful to relate the positions of planes to each other.

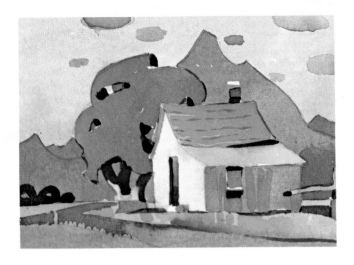

Formal or Harmonic
The vibration of the different wavelengths of light (color) is comparable to musical pitch. The effect may be independent of the subject.

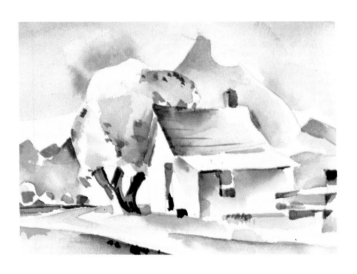

Simultaneity
Color contrast is greatest at the meeting point of different hues, causing each to move toward the opposite extreme. This permits limitless color relationships.

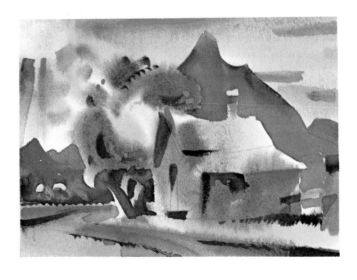

Emotion
"I saw red." "He felt blue." "She was green with envy." Such popular expressions remind us that colors associate with feelings and can, therefore, be used to convey emotion.

Local color abstract
of farmhouse (opposite) indicates
that it will be a difficult basis for
color selection. The white walls do
not make a very satisfying pattern.

Warm/cool pattern,
based on sunlight and blue,
nonlight, provides sufficient
alternations, especially in the white
walls and blue sky, to make a
rhythmic checkerboard of color
relationships. It can replace dark/
light as a means of suggesting
volume.

Local Color Related to Light/Shade
Study the band on the white
cylinder to see how the local color
(red) can change as hue when
affected by the *temperature* of light/
nonlight.

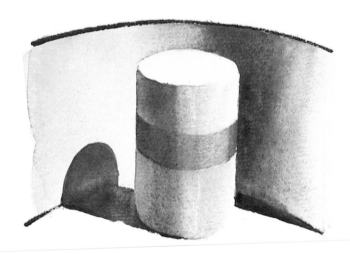

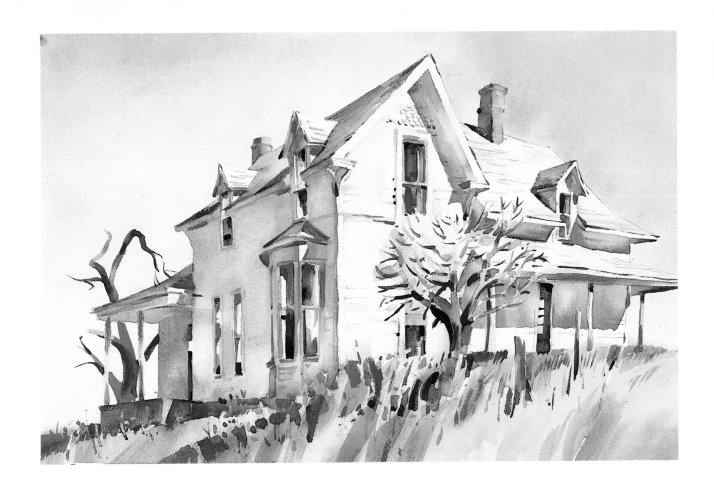

Relating Color Schemes

Most successful paintings swing on just one color scheme whether it be light, emotion or other. But once a viewpoint is adopted, aspects of other motifs can be introduced. For example, this demonstration is based on color as light/shade which establishes a framework to accept additions of local color as well as the intensification of simultaneous contrast.

Compare these examples to the chiaroscuro based on the same subject, page 81.

Superimposition

A semitransparent glaze of cobalt blue has been carried over the sky and mountain, setting the distance back and creating a vibration with the underlying purple, yellow, and blue pigments.

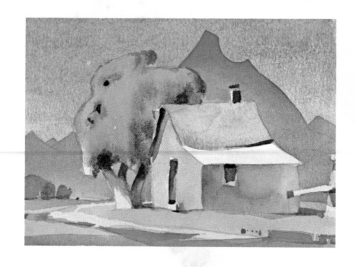

Juxtaposition

Dots of alizarin crimson establish the local color of the house. The addition of dots of yellow in sunlight, blue in shade, cause the red to appear as two secondary colors, orange and purple.

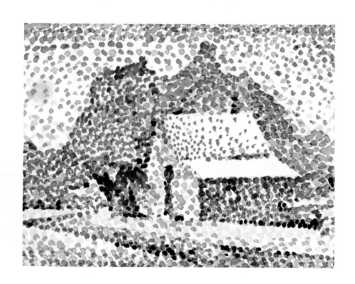

Halation

The near corner of the house is perceived as a green. This causes the adjacent red (local color) to vibrate against it.

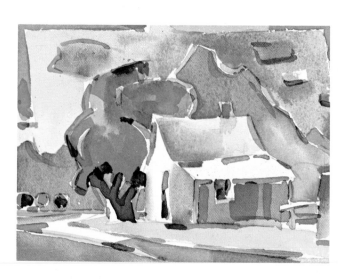

Resonance

Color comparisons become complicated, both perceptually and technically, by what I shall describe as a third-note capability. This presents a challenge to the painter and, at the same time, provides a way to orchestrate his pigments. Four manifestions:

1. Superimposition

Aerial perspective influences the color of shapes in the distance by a veil of atmosphere which vibrates between near and far. In the same way, when pigments are layered in the indirect (glazing) technique, an optical quality is created which is not evident when the same pigments are mixed as one. Light reverberates between paint layers, creating a luster comparable to the nacreous interior of a sea shell. Examples: Rubens and Rembrandt, in oil; the English of the nineteenth and twentieth centuries, in watercolor.

2. Juxtaposition

When pigments are set side-by-side in small, repeated units, they appear to combine optically to create a resonant third color which is more vibrant than when the same pigments are mixed as one. The effect has been employed historically by mosaic and stained-glass artists, but it is best illustrated in the oil paintings of the neoimpressionists.

3. Halation

An hallucinatory third color often appears between two clear colors, especially in strong light. Cezanne seemed to see it as blue; Matisse, as the complement of one of the adjacent colors. His widely reproduced portrait of his wife, *The Green Line*, reveals it as a vertical bar between two warm colors. Wayne Thiebaud appears to relate it to the physical primaries of light, green, violet, or red.

Whether perceived or improvised, halation provides a means of intensifying color relationships.

4. Neutral Modulator (example, page 20, stained glass)

When two adjacent colors are separated by a black line—the leading in a stained-glass window, for example—they can vibrate more intensely than when juxtaposed.

Examples: Many Byzantine icons and mosaics; the paintings of Georges Roualt and Max Beckman.

Resonance:
Reinforcement of a tone by reflection of sympathetic vibration of other bodies.

Color Characteristics

Major

Major
refers to those characteristics of color which can be scientifically measured.

Hue: The name of the color, product of its wavelength. For example: Orange with a wavelength of 590 affects the optic nerves differently than blue with a wavelength of 484.

Value: A measure of brightness or reflectance. This can be read as footcandles of light by using a photographer's exposure meter. Yellow, for example, is lighter than green.

Intensity: An indication of the saturate purity of a given wavelength. Intensity may be reduced by adulterating a wavelength with any other wave.

Before going further, learn to use terms correctly. Don't say "A *shade* of blue" when you mean "A *hue* of blue." And if the blue is modified by green (for example) say "green-*blue*", not "blue-green." Remember that the name of the dominant color comes last.

Minor

Minor
refers to subjective qualities of color.

Temperature: Red-orange is hot, blue-green is cool, but the terms are comparative. For example, red appears warmer if an orange-red, and cooler if a purple-red. Sunlight is described as warm compared to shade and shadow, but it may appear cool contrasted with firelight.

Distance: Warm, light colors appear nearer than cool, dark ones.

Weight: Red and purple appear heavier than green and blue, although their value indexes may be similar. In general, most dark pigments seem heavier than light ones.

Tempo: Colors with long wavelengths (red and orange) seem livelier than those with short wavelengths (blue and green).

Expansion/Contraction: Blue may recede when compared with red, for example, but at the same time it appears to expand laterally. This effect is most apparent in comparing colors in a stained-glass window and requires the window designer to compensate by increasing the width of the black divisions between blue shapes while reducing it between the reds.

98

Individual Preferences

Psychological: Associations with earlier experiences may greatly influence an individual's color preferences. For example, the soft gray warm-green hue described as "G.I. green" is often shunned by former servicemen who associate it with unpleasant experiences during the war. Blue appeals to many people but seems morbid and cold to others.

Symbolic: Certain colors may assume an extra significance through tradition, habit, or training. For example, red seems to flag the attention and spur action for some while signaling "stop" to others. Red, white, and blue have a special meaning to Americans, who associate the combination with the national colors.

Anthropological: Blue-eyed Nordics favor cool colors; warm-eyed Latins, warm tones. Perhaps the dominant colors of their native environments explain these choices.

Sex: Although psychologists are not in complete agreement, it is generally established that women are more color sensitive and that their color preferences are different from those of men.

Age: The young prefer intense colors and strong contrasts while the older generation opts for greater subtlety of both value and wavelength.

Intelligence: Studies reveal that the greater the intelligence level, the greater the enjoyment of subtle color differences, and vice versa.

Physiology: Individual differences in color perception affect the ability to estimate time, size, and temperature. For some, time seems to pass more slowly in a yellow room than in a blue room. Most individuals are happier surrounded by warm colors rather than cool ones of the same value and intensity.

A predominately warm-toned painting will outsell a cool-toned work two-to-one.

—*Dalzell Hatfield,
art dealer*

I like any color, just so it's blue.

—*overheard*

EMPHASIS

MOVEMENT

RHYTHM

What Color Does for the Painter

To the painter, color—like line—is not so much an experience, but rather a *way* of experiencing. As pigment it becomes symbolic, capable of suggesting all sorts of associations. Here are some:

The Color of Light in Nature

As atmosphere: Water and dust particles act as veils, progressively neutralizing hues as shapes extend into the distance. This *aerial perspective* supplies an orderly way to suggest depth.

As directional light: The temperature of a single light source will modify everything that it strikes and cause the nonlight (shade/shadow) planes to polarize in the opposite temperature. For example, sunlight will appear yellow, causing shade/shadow to appear blue; the blue light from a skylighted studio will cool those planes turned toward it, appear to warm those away from it. In this way color can model regardless of value (refer to page 94).

Color as a Signal

Local color: We don't see pure local color; we think it and read it. Because it identifies objects, the painter can use it to separate things in his work. For example, a *red* apple, an *orange* pumpkin, a *green* tree.

For emphasis: Intense colors are perceived before muted ones of the same size and in the same position. This provides the painter with another way to stage-manage his drama.

For emotion: Because colors tend to be associated with other sensual experiences, they can create different emotional reactions. For example, red and orange seem more vital and full of energy than blue or green; purple, by comparison, appears even quieter and more reclusive.

For movement: By replicating the rainbowlike progression of hues around the spectrum, the painter can create a feeling of movement comparable to an arpeggio.

For rhythm: By alternating two colors continually as in a checkerboard, a drumbeatlike rhythm can be established.

By induction: The phenomenon of simultaneity provides a way to cause a neutral black, white, or gray to appear as the complement of an adjacent color (refer to examples, pages 89 and 93).

Formal or Harmonic Color

There are many theories of color combination, including the influences of position, size, and intensity. A fundamental theory is that of harmonic wavelengths (hues). Colors closely related as hues are said to "harmonize," while contrasting hues—red/green, blue/orange, yellow/purple, and so on—have another kind of relationship as complements (reciprocals) of each other. Some of the more basic modes of combination are the following:

Monochrome: One color modified by value (tints and shades) only.

Analogous: Hues immediately adjacent are added to the scheme.

One color + neutrals: Black, white, and gray are juxtaposed with a monochrome.

Complementary: The opposite hue on the spectrum is introduced, usually as subdominant to the primary color.

Semi-triad: A color, its complement, and one of the two hues midway between.

Split complementary: A color and the two hues adjacent to its complement.

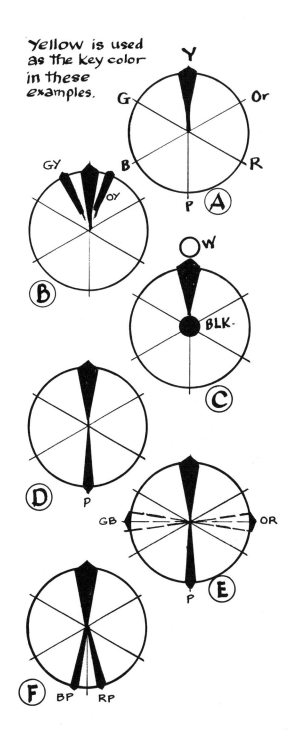

Yellow is used as the key color in these examples.

When Pattern Becomes Texture

Three walnuts are a pattern; so are five or six. But, when there are seven or more similar units, we have a texture. The pattern is now the shape of the cluster. For this reason it is necessary to repeat textural units seven or more times.

Formal Texture: Overall Patterning

Like local color, formal, overall patterning is most easily perceived in direct light. The tree displays its leaves one by one; a brick wall is formally enriched; clapboards and shingles march as if to a drumbeat. These textures are explicit in comparison to the suggestiveness of informal, sidelighted surfaces.

The problem of overall texture is that it can conflict with color and value. Together they can be more than the eye can accept, especially if the texture is random or excessively bold. For this reason, painters restrain such surface treatment, giving such areas a light and methodical touch.

Examples: Raoul Dufy, van Gogh, the Oriental artists.

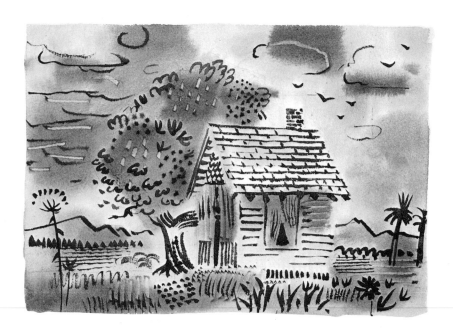

102

Texture

Of the major plastic elements—line, value, color, and texture—texture is the least important. Some painters ignore it, painting everything as if made of tin or wool. Others use it instead of color (Andrew Wyeth, for example). It does contribute a tactile feeling and it can operate emotionally, in somewhat the same way color does.

Texture is manifested in two ways: as an overall patterning like floor tiles, a tweed fabric, or a wallpaper figure, or, at the edge between light and shade or objects. The painter creates texture by duplicating one or both of these effects.

Why use it:

1. it appeals to the sense of touch
2. it can enrich a surface, increasing its weight
3. it can help identify objects by their surface appearance
4. it can re-order the importance of shapes by its use or nonuse (see next page).

Informal Texture: the quality of the edge

When we study the moon through a telescope, we discover that its blemishes are pockmarked craters. This is observed at just two points; the meeting point of dark and light, and at the outer edge. Experience has taught us to assume that the areas in between are textured similarly. In a like manner, we accept the roughness of leaves at the edge of a tree as proof that leaves on the entire tree have rough edges. Our reaction is *informal*, unsupported by definite information.

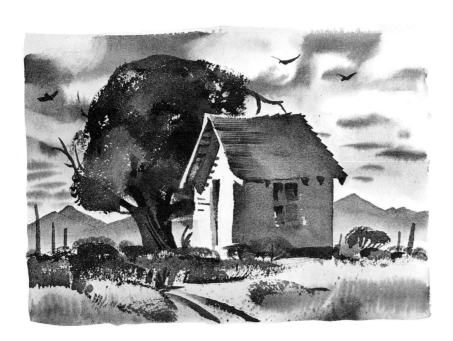

The Hierarchy of Edges

By manipulating the brush, a painter can create a range of edges from rough and hard to smooth and soft. This achieves two objectives: texture is implied to the shape without the need for a formal, overall patterning and, perhaps more important, the attention of the eye can be controlled in a predictable fashion.

The hierarchy of attention as influenced by edge is illustrated:

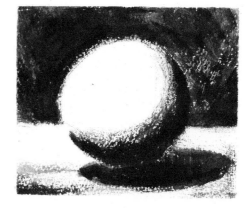

A rough edge is perceived before a smooth one.

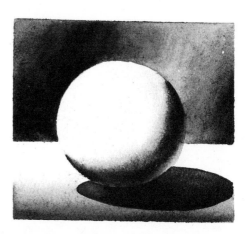

A smooth edge is seen before a soft one.

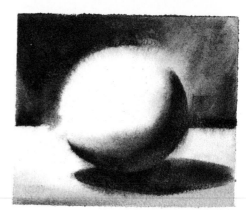

Soft-edged shapes are perceived last.

COMPOSITION

Composition:
Organization of an idea in terms of the medium.

Considerations

—A blank sheet of paper or a canvas has unity.

—The grid provides a way to relate and compare sub-
divisions of the picture plane.

—Alternation endows the grid with a heartbeat.

—The arabesque is the design line of two-dimensional art.

—The eye perceives but it is the hands and feet that react
to space.

—The illusion of the third dimension is composed by treat-
ing depth as a maplike pattern.

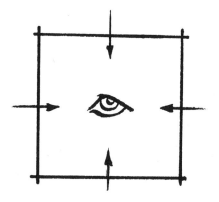

Pull of the Middle

A blank sheet of paper or a canvas has unity. The painter's problem is to add variety without losing it. One solution is to treat the surface uniformly, minimizing variety. This is the way of color-field, minimal, and serial painting. Another solution: Treat additions as a grille or meshwork through which the unity of the field is preserved.

If it is the artists' wish to add variety to the surface, for either enrichment or expression, the centripetal action of the picture plane provides containment better than any frame. Like the eye of a hurricane, the central part of the canvas becomes the nucleus around which shapes and colors gather. The inward pull achieves the first objective of composition, unity.

Once the composition has captured the eye and drawn the spectator into the painting, a compensatory action is needed or the experience will terminate in a spiral swirl like water draining out of a bath tub. Somehow the eye must be freed to rove and read the surrounding parts, returning to the focal center from time to time as a reference point. If the composition does not release the spectator to do this, it fails the second test, variety.

It is important to remember that the focal center is seldom a "thing," nor is it often exactly at the middle. Picasso, for example, favored a termination well above the center; Edward Hopper, on the other hand, aimed below the middle and to the right; Andrew Wyeth, above the middle and to the right. The individual and his communicative needs will determine the ultimate location.

The critical test is to answer the question: Does the composition progress inward, centripetally, or implosively, or does it fall apart?

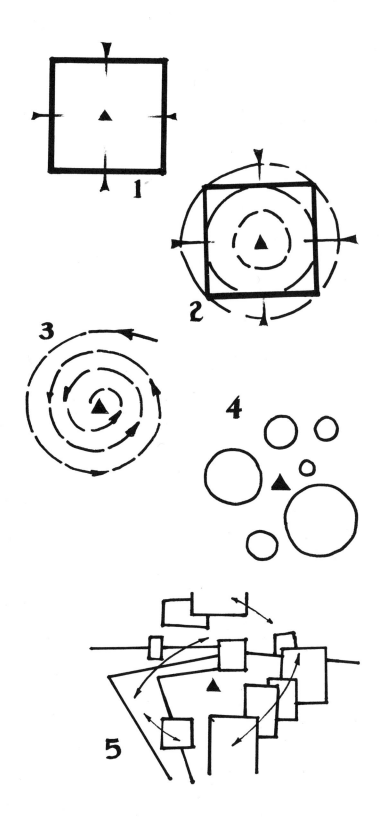

1. A shape has a magnetic or gravitational pull toward the center.

2. The pull of a shape extends beyond its perimeter but is strongest toward the middle.

3. The interaction of the painting field with the pull of the center creates a spiral toward the middle.

4. The focal point is seldom a thing but is rather a position, as is demonstrated in this cluster of shapes.

5. In three-dimensional composition, the focal point moves toward the middle in depth, thus permitting shapes to circulate around it, not just in front of or behind it.

Modes of Pictorial Organization

Non-hierarchical Form: The Undivided Surface

> The canvas becomes the symbol of unity rather than do organizational hierarchies in which dominant elements bring lesser ones into subordination.—*Jackson Pollock*

A piece of canvas, a sheet of paper, a blob of paint have inherent unity, as we have just observed. If one will stay within these disciplines, the problems of pictorial cohesiveness need not arise and yet the possibilities for dramatic effect exist.

Examples: Mark Rothko, Jules Olitski.

Modular Division

When the surface is subdivided into identical units like a fishnet, surface tension seems to increase and the modules cohere.

Compare a brick wall to a flat plastered surface to observe this effect. This is the basis of serial painting. More exciting things happen, however, when the units are square, the product of interlaced horizontal and vertical coordinates. The result is a screen, a grid, or a grille with a regular rhythm which provides a way to measure relationships of shapes, and, when aligned with the gravitational verticals, provides a means of comparing static and dynamic relationships.

Hierarchical Form: The Image Appears on the Plane

Symmetric Division, the Checkerboard

Alternation is as fundamental to the language of pictures as simultaneity is to visual perception. Whether the surface is articulated by color, value, or texture, contrast must occur like the moves on a checkerboard. When the moves are symmetric—regular in the pattern of alternation—the surface acquires a rhythmic heartbeat. Serial painting and overall patterns are examples: Jasper Johns, Mondrian, and Klee.

Asymmetric Division, Tensional Balance

When the modules are grouped in clusters of various size, the action of the checkerboard is intensified. Example 1 demonstrates the rotational movement that occurs when the groupings are diagonal to each other. When the clusters are of uneven size, Example 2, the movement is greater. To some degree all hierarchical paintings are checkerboards, even those in which the curve or the diagonal predominate.

Examples of this motif: Velasquez' *Maids of Honor;* Renoir's *The Boating Party;* works by Poussin, Mondrian, Seurat.

Variations on the Checkerboard

At least four additional motifs occur in painting, each symmetric but, as we see on the following pages, capable of asymmetric treatment. They are the *vertical, horizontal, cruciform* and *frame-in-frame* motifs.

1

2

Vertical

From the moment a child first lifts his head or attempts to stand, he experiences the pull of the vertical. This is the direction of growth, the spirit of the forest interior, the pathway of rain and sunlight falling on the earth. Little wonder that religious painters such as El Greco made it the motif of their compositions, elongating both the format of the work and the figures within. It is the obvious choice for the painter of the human figure for some of these same reasons.

1. When the vertical bars are aligned symmetrically a feeling of monumentality occurs, as if one were standing in a Greek temple. The gravitational field holds them together.
2. Tension develops when the vertical units are of different sizes—or colors or values.
3. Staggering the verticals slightly causes the units to acquire an almost human quality.

Examples range from the symmetric alignments of early Italian painting (Piero della Francesca and Masaccio) to the exciting warped verticals of Picasso's *Les Demoiselles d'Avignon*.

3

Horizontal

As fundamental as the vertical, the horizontal is expressive of earth and sky. Doubtless this is why it is the favorite mode of landscape painters. Man identifies easily with its secure and restful qualities.

1. When the horizontal bars are arranged in symmetric parallelism—like the stripes of the American flag—a feeling of extension is induced. The gravitational field of the picture plane provides an unseen but useful device to contain this movement without actually arresting it.
2. Because the bottom of the painting feels related to the earth (regardless of how abstract the concept), the lower bars seem to require more weight of value, color, or texture.
3. When the stratification is not exactly parallel, tension and movement increase, creating a feeling like a heaving sea.

Examples range from Chinese scroll painting to Venetian landscape, and from Whistler's color-bar studies to the watercolors of Californian Phil Dike.

1

2

3

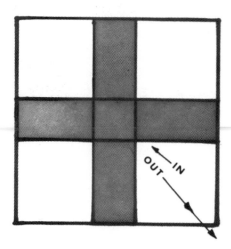

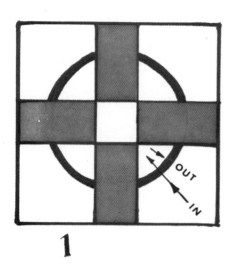

1

2

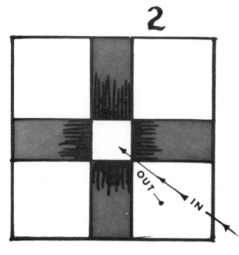

Cruciform

Concentrating the vertical and horizontal motifs as a cross (cruciform) creates the ultimate dramatic effect. The spiritual uplift of the first motif unites with the pragmatic horizontality of the second like a clap of thunder. The intensity of the crossing is as hypnotic as a look at the sun. It is a widely used symbol in religious art ranging from Byzantium to the Hopi Kachina.

The problem of the cruciform is certainly not one of arriving at the focal center but, rather, how to meaningfully relate the four areas which support it.

There are at least two solutions:

1. Contain the four segments by developing the concentric movements of the arabesque, like a Celtic cross. The nimbus surrounding the Holy Family is another example.
2. Treat the center so dramatically that the eye is pulled inward, thus nullifying the importance of the corners.

Examples: abstract expressionism, western religious painting.

Frame-in-Frame

André L'Hote describes this motif as "Composition by Closure"; Kenneth Clark as "The Painting as a Closed Garden." At best, isolating the design from the wall by a border or frame-shaped separation achieves an intimate, precious quality. At worst, such closure is a forced way to achieve unity.

Contemporary art has provided ways to hold the parts together dynamically—as suggested in this manual—thus eliminating both framing movements and the need for the frame itself; but still such twentieth-century painters as Picasso, Braque, Ben Nicholson, and John Marin base each composition on its power to isolate.

Marin was apparently conscious of its restrictive tendencies for he devised openings and passageways in the surround to lead the eye inward. He also experimented with extending the painting outward by continuing shapes onto the frame itself.

Today's competition for the eye, with canvases so huge that the spectator feels he can walk into them, has relegated the frame-in-frame form to a less important place than it had in the past.

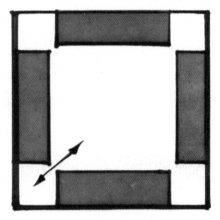

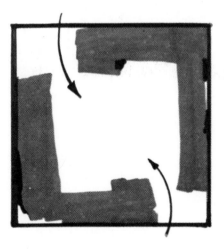

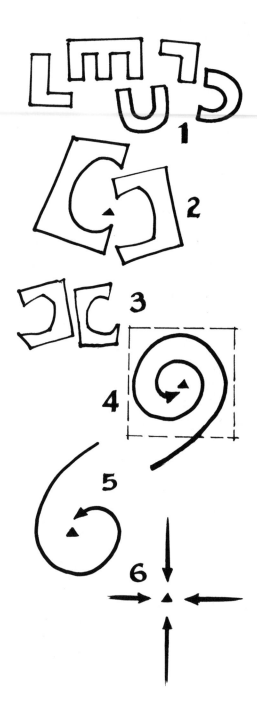

Arabesque

In the time-arts such as music and literature, the *design line* is one directional, proceeding from the introduction to the conclusion. The dramatic development of the artwork is defined by a series of ever steeper peaks and hollows. In painting, where time is unlimited, the design line becomes an inward spiral movement. Or, it can be visualized as a series of interlocking shapes progressing from the frame to the focal center.

1. Interlocking shapes are like gripping fingers. The letters "L," "C," "U," and "E" are typical. (Refer to Interlock, pages 48–49).
2. **and 3.** Interlocking shapes must turn toward each other. When they turn outward they direct attention off the canvas.
4. The design line commences beyond the frame in many, but not all, cases. It may progress gestatively like Michelangelo's *Last Judgment* or a Sung landscape.
5. It may move more rapidly, as in most twentieth-century paintings.
6. It may move instantly to the focal point, like an atomic explosion.

Example: abstract expressionism.

Movement

1. Most design lines enter from the base of the painting, taking the eye and the feet into the picture as if the spectator were drawn to a doorway.
2. It can enter from the top, like a burst of heavenly light in a Tiepolo religious composition, or a cascade of mountain ranges in a Chinese Sung landscape.
3. It seldom enters from either side. Arnheim suggests that this may be because the pull of the gravitational field is absent in the horizontal.
4. The arabesque presents a technical problem in that it crowds the important center area while opening space toward the edges.
5. The artist learns to compensate by increasing the size and importance of shapes at the middle, minimizing them at the perimeter.
6. When linear perspective is employed it exacerbates the pinching of the center.
7. A solution is to reduce or invert perspective causing shapes to expand away from the borders.
8. Cezanne explored the problem of the crowded and hollow middle in his studies of Mount St. Victoire as viewed from the distance of his studio at Aix.
9. He opened up the middle by increasing the scale of shapes in depth, and he strengthened the circulatory arabesque movements of shapes into and from it.

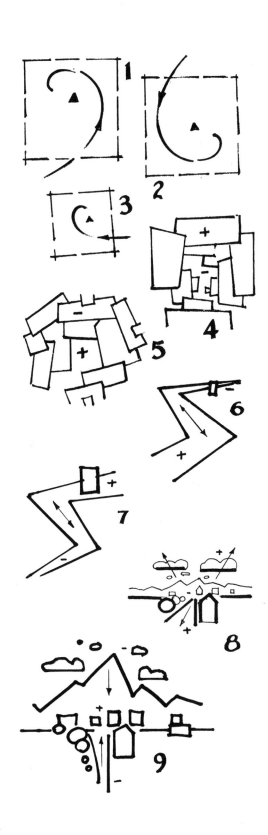

115

Interplay of Form and Content

Both form painters and content painters acquire some inhibitions along with increasing skills, the worst of which is a tendency to compose in stereotypes. One successful horizontal bar design invites another and then another; one dashing surf pattern breeds duplicates, possibly at the expense of other wonderful experiences. The following exercise suggests a way to break the mold of such habits.

Procedure: Without regard to subject matter, prepare five canvases or sheets of watercolor paper with the five motifs just discussed. Paint each pattern in a muted, warm color with whites left between shapes. Take these to the subject and select from it shapes appropriate to the mode. Use a middle gray-blue to develop this secondary pattern. Finally, add accents of black to underscore the theme.

This example is from my studio in the San Juans. It helped me to see other possibilities in the view.

A. The subject.

B. Checkerboard (asymmetric).

C. Vertical bars.

116

D. Cruciform.

E. Frame-in-frame.

F. Horizontal bars.

Composing the Third Dimension

To some degree every hierarchical painting has a feeling of space. There is even an up/down quality to a checkerboard. An invitation is presented to the hands and feet, *via the eye*, to move about. We see the vase of flowers but it is our hands that *feel* they can encircle it. We see the image of a house but it is our feet that tingle to *walk* to, through, and around it.

Pictorial depth can be managed in a way to avoid holes and dead ends. More, it can provide exciting, rollercoaster sensations. Picasso gloried in such plasticity in his early cubist and classic periods. Later, however, he nullified the illusion of space (the *Guernica*), seeking instead to make flat symbols.

Conceive of the painting as a shallow theatrical stage in which action is contained. The background a cyclorama, like the sky, contained overhead by the curtain. The stage floor, like the earth, a plane on which depth and movement are compared. The props and "flats," the shapes which define space and create action.

The studio shadow box is analogous and functions in the same way with the model or still life at its center.

Spatial movement can be analyzed two-dimensionally by visualizing it as a floor plan, the various objects seen as planes from above. Such a viewpoint will immediately indicate whether there is a circulatory pattern or not.

Opposite page:

A. Regardless of how abstract the concept, the surface appears to divide into a heavier, ground plane and a lighter, sky plane, creating an envelope of air and light.

B. The studio shadow box confines space like a stage set.

C. The ferris-wheel *vertical* movements and the carousel-like *horizontal* circulation unite to provide containment to the three-dimensional design.

D. Depth can be created in the same manner, as in theatrical staging.

E. A bird's-eye (plan) view of the scene makes the three-dimensional circulation more understandable.

118

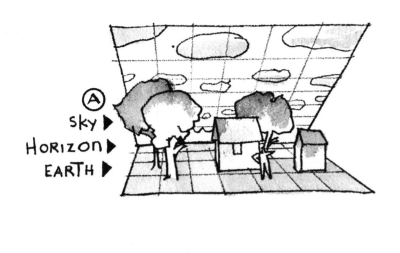

A

SKY ▶
HORIZON ▶
EARTH ▶

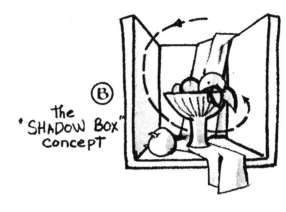

B

the "SHADOW BOX" concept

C CONTAINMENT visualized as circular — or spiral-movement

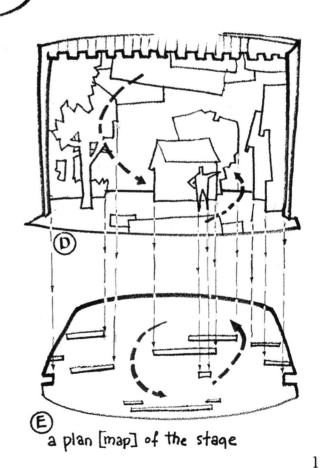

D

E a plan [map] of the stage

119

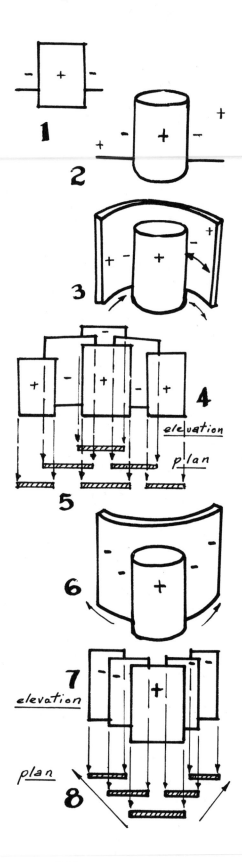

Dynamics of Space

Containment

1. A shape which appears to be superimposed on other shapes comes forward, causing the surround to sink.

2. When the shape is modeled, the illusion is intensified at the conjunction of the areas, but the surround springs back to the picture plane as it recedes from the point of contrast. The result is an optical "warping" of the background plane in compensation, as in 3.

4. and 5. A plan view of the give and take of background and foreground shapes reveals the push/pull relationships which occur, and indicates why they are satisfying.

6. If the painter thwarts the compensatory return of the background to the picture plane, as in this example, the sense of the picture plane is lost. Instead of a "bas-relief," the painting becomes a background for the object, of no more importance than a wall behind a piece of sculpture.

7. The problem is analyzed as a series of overlapping planes.

8. An overhead (plan) view of the planes reveals the divisive condition which is created when space does not return to the picture surface.

Circulation

9. Movement into space can defeat the two-dimensional direction of pattern as is demonstrated in these examples.

A. The eye/mind/feet are drawn from the left to the right.

B. Even when pattern expands to the left, the "eye" is drawn to the right.

C. Movement to the right is more satisfying when the termination is a larger shape.

If one analyzes these patterns, as in Example 8, opposite page, it becomes apparent why such unrequited directional movement is unsatisfying. It also explains why a receding line of coastal cliffs or a street of houses is difficult to relate to the two-dimensional nature of the canvas.

10. The solution to the problem of shapes driving off the picture is to introduce a compensatory return, thus completing the arabesque in space.

11. When a central shape is added, rotation and counter-rotation increase. (Donald Graham has described this effect as "the whirling plan" or "the swing around.")

12. Because there is more space at the perimeter than at the center, three dimensional design (like two dimensional design) tends to become crowded toward the middle (A). The solution: increase the size of shapes toward the center (B).

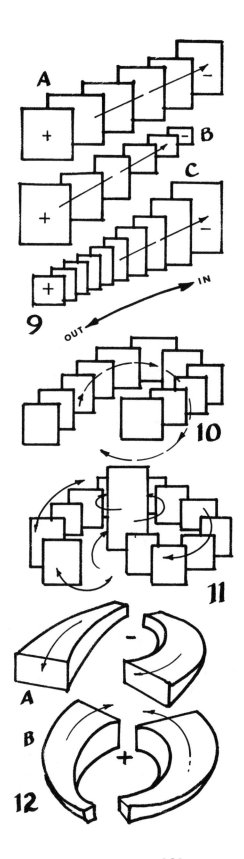

Two versus
Three Dimensions

The appeal of pictorial depth comes at a price. Its hills and hollows can destroy the continuity of the painted surface. Color, which has its own push/pulls, becomes competitive with it. The symbolic power of shapes suffers. For such reasons few painters exploit space, preferring to suggest rather than specify depth.

The alternatives are compared in these versions of the same compositional drawing (refer to the subject, page 66).

The example above nullifies space by avoiding intersection, overlap, and deep perspective. Such an approach opens the door for color.

The drawing at the right emphasizes space by stressing the nodal points (the intersections of shape with shape).

First, a Feeling

These two thumbnail studies derive
from the drawing, opposite—the format
of one, vertical, the other, horizontal.
The compositional motifs reflect the
formats. What is important is that each
is expressive of something *felt* more
than perceived.

Look, think, and study! Learn to
manage the tools of painting. But yield
everything to your heart. *Let feeling
guide your eye and hand.*

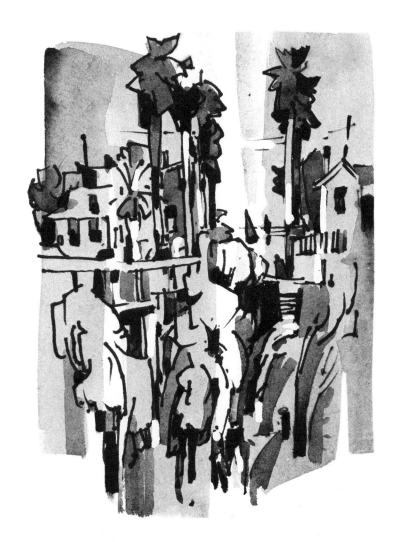

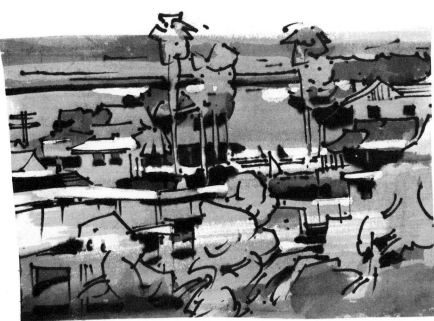

Acknowledgments

To our students, to our painter friends—many of whom have been guest artists at Blue Sky, to my many fine teachers, to my long-time publisher, and to Joan and Flo, who once again have seen me through some words, affectionate regards and deep gratitude.

Bibliography

Arnheim, Rudolf. *Art and Visual Perception.* Berkeley: University of California Press, 1954.

Arnheim, Rudolf. *The Power of the Center.* Berkeley: University of California Press, 1982.

Cheney, Sheldon. *Expressionism in Art.* New York: Tudor, 1939.

Chevreul, M. E.: *The Principles of Harmony and Contrast in Colors.* New York: Van Nostrand Reinhold, 1967.

Clark, Kenneth. *Landscape into Art.* New York: Harper and Row, 1976.

Feldman, Edmund B. *Varieties of Visual Experience.* New York: Abrams, 1971.

Franck, Frederick. *The Zen of Seeing.* New York: Vintage, 1973.

Gore, Frederick. *Painting: Some Basic Principles.* New York: Reinhold, 1965.

Graham, Donald W. *Composing Pictures.* New York: Van Nostrand Reinhold, 1982.

Hoffman, Hans. *Search for the Real.* Addison Gallery of Art, 1948.

Huyghe, Rene. *Ideas and Images in World Art.* New York: Abrams, 1959.

Knobler, Nathan. *The Visual Dialogue.* New York: Holt, Rinehart and Winston, 1971.

L'Hote, André. *Treatise on Landscape Painting.* London: A. Zwemmer, 1950.

Loran, Erle. *Cezanne's Composition.* Berkeley: University of California Press, 1943.

Index

INDEX OF ARTISTS